IMAGES
of America

DINUBA

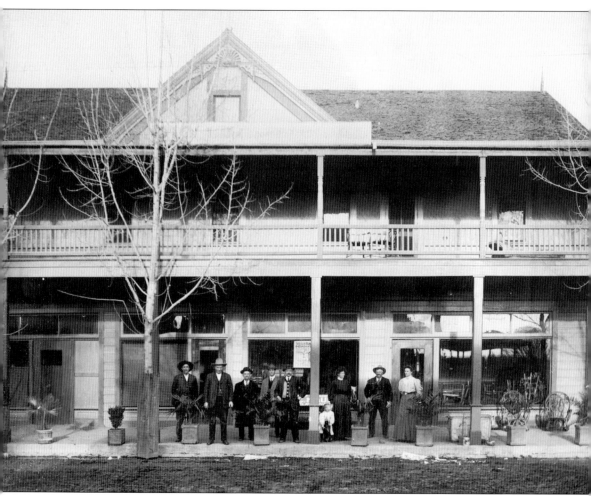

This is the Sibley Hotel, later called the Dinuba Hotel. It was a center of activity for many years, offering entertainment and food. It burned prior to 1900, was replaced with a brick building that burned in 1901, and was rebuilt again. The hotel still stands today in the same location, although without the facade. The first curfew bell was placed behind the hotel and was rung every night by the town marshal, announcing it was time for all of the saloons to close and everyone to go home. This photograph was taken at Christmastime about 1890. There is a sign in the window that announces "Wells Fargo and Co. Season's Greetings Express Forwarders Special Attention given to Holiday Presents." (Alta Historical Society.)

ON THE COVER: This is a photograph of the Raisin Day Parade, likely in 1914, stretching for over a mile. It was the first parade in Dinuba after the celebration had been lost to Fresno for a few years. Since regaining the celebration, Raisin Day Parades have been a key part of Dinuba culture for over 100 years. Usually in September, after the raisin harvest is completed, the entire town celebrates with a parade on the same street, a carnival, and food booths from the entire county. (Alta Historical Society.)

IMAGES
of America

DINUBA

Ron Dial

ARCADIA
PUBLISHING

Published by Arcadia Publishing
Charleston, South Carolina

Printed in the United States of America

Library of Congress Control Number: 2015954774

For all general information, please contact Arcadia Publishing:
Telephone 843-853-2070
Fax 843-853-0044
E-mail sales@arcadiapublishing.com
For customer service and orders:
Toll-Free 1-888-313-2665

Visit us on the Internet at www.arcadiapublishing.com

This book is dedicated to the many and diverse families that moved here and created the town of Dinuba and its rich history.

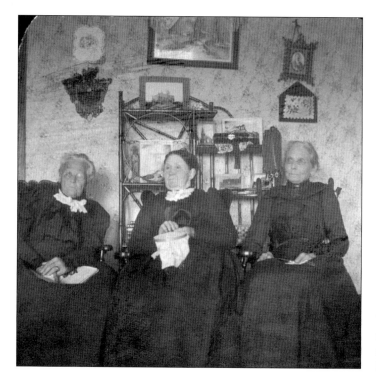

This is a photograph of the Patterson, Leibau, and Newton matriarchs. (Newton family.)

CONTENTS

Acknowledgments

Thanks to Connie Alvarado, the estate of Robert Gapen, the family and estate of Karl Newton, Elmira Leibau, Barbara Richardson, Janice Moore and the estate of Ray Woolley, Bob Raison and the *Dinuba Sentinel*, the *Alta Advocate*, Jeff Belknap, Ron Parmenter, Dopkins Funeral Chapel, the Alta Historical Society, the Tulare County Historical Society, Arlo Westmoreland, the estate of Shorty Kelly, Barbara Martzen, Martzen Studio, Dinuba Christian Church, Dinuba Baptist Church, Dinuba Presbyterian Church, Dr. Marn Cha and the Central Valley Korean History Project, Dinuba High School, the Olson family, the Dinuba Chamber of Commerce, the Dial family, Bud and Karen Vetter, the Rivas family, Marcia Williams, and the Jake Enns family.

The author is also thankful for the work and original photographs from the past 130 years, restored by Ron Dial, of the following photographers: David Martzen, Louis Mitchell, "Flash" Gordon, Allen, Kaiser, and Canal.

INTRODUCTION

In 1864, toward the end of the Civil War, the ravaged farms of the South were struggling against a severe recession. Facing long-term hardships, for some farmers, California represented a dream of a positive future. It was just 14 years after the Gold Rush, and moving to California was a way to escape the problems of the South.

Some of these Southern farmers decided to immigrate to California and start a new life. Leaving Missouri, they traveled by wagon train through the Sierras to Northern California. When they arrived in Red Bluff, they found that all of the farmland had already been taken. Rumors of good land to the south sparked another trip to Tulare County, one of the few places with available land. The arable farmland of Tulare County was principally in the Mussel Slough–Grangeville area.

The main cash crop at the time was wheat, with a bag of flour selling for $1. The quickest way to produce wheat was to look to the land in Mussel Slough. This land was adjacent to Tulare Lake. Each winter, the Kings River would flood the Mussel Slough with sufficient water when augmented with canals to grow wheat for an entire season. In *Garden of the Sun*, Wallace Smith writes, "Newspapers reported that Mussel Slough was the perfect place for agriculture. The snowy Sierra and Coast Range and the well tilled, well irrigated fields show why this is truly one of the finest garden spots in California." At the end of the growing season, the hot, dry weather made the wheat very dry and very valuable, because it was more stable than Midwestern wheat when stored. Within one year, a farmer could have a tidy profit.

So a group of Southern farmers came to Mussel Slough, bought land, and began farming and shipping wheat from the new town, Traver. Founded in 1884, Traver was booming, with seven hotels, saloons, restaurants, merchants, and wheat storehouses. By 1886, Traver shipped 32,214,517 pounds of wheat. In the first seven months of 1887, 34,407,100 pounds were shipped, with 30 million pounds still in storehouses. To this day, this represents the greatest amount of wheat ever shipped from a single location. Things were busy. The 1880 Census recorded that there were more people living in Tulare County than in Fresno County.

But paradise was not to continue. By 1870, the Southern Pacific Railroad had been granted federal land patents for all land 10 miles to either side of the railroad right-of-way, which ran through Mussel Slough. The railroad came to the settlers and notified them that they would have to repurchase their land for more than they originally paid for it. An intense legal battle ensued. Settlers formed the Grand Land League and sued the railroad in state court several times and won. But the railroad claimed that its patents were federal and that the state courts had no jurisdiction. Arguments and threats continued. The railroad ignored the California Supreme Court, which sided with the settlers and their deeds, and set out to enforce its own land rights. Tempers were running high.

Thomas Jefferson McQuiddy, a former Confederate cavalry major and outspoken critic of the railroad, allegedly gathered troops and drilled them in the streets of Hanford. The events that followed inspired the formation of Dinuba.

The various claims for the land boiled over when US Marshal Alonso Poole was dispatched from the San Francisco offices of the Southern Pacific Railroad with federal court writs of eviction for the settlers. Upon arriving in Hanford, Marshal Poole was greeted by settlers and told to go back home. The marshal ignored the crowd, checked into the Hanford Hotel, and the next day, arrived at some farms accompanied by new "owners" from Visalia, all armed and at least one of them considered a "hot head." The same afternoon, the Grand Land League was having a picnic along the Kings River. Upon hearing of the evictions underway, a large contingent, led by James Patterson, grabbed their weapons and set off to stop the evictions.

Arriving at one farm, the league confronted Marshal Poole, a land appraiser, and the two individuals from Visalia who laid claim to the farms. Furniture from the homes had been removed and was alongside the road. During the ensuing argument, someone fired a shot, and a gun battle erupted, leaving seven dead. Had Alonso Poole been named Wyatt Earp, the shooting would have become popular history. As it was, it was the deadliest shooting in the West, becoming known as the Mussel Slough Tragedy. It inspired the novel *The Octopus* by Frank Norris (1901) and several other books. But this did not end the fight for the land. The settlers were soon arrested. John D. Purcell, James Patterson, William Braden, John J. Doyle, and Wayman L. Pryor became known as the Mussel Slough Five. Patterson was considered to be the leader.

The Mussel Slough Five were prosecuted for murder but only found guilty of assault on a federal officer. They were sentenced to six months at the San Jose Jail, but they served their time at a local hotel under the hospitality of the local sheriff. After six months, the US Circuit Court released all five. This outraged the Southern Pacific, and the political battle between the two factions raged on for years. The shooting galvanized the state.

Two years after the shooting, James Patterson attempted to reach a settlement with the railroad, offering to purchase the land. The railroad declined, and a new problem arose.

The wheat gradually stopped growing in some areas. The University of California reported that subterranean alkali was percolating to the surface, caused by the heavy spring flooding and canal irrigation. Alkali was poisoning the wheat. The poisoning was originally in the Grangeville area but continued to move north toward Traver. Fearing the worst, Patterson and some friends again pulled up stakes to move to a new area north of Traver with no houses, just a railroad stop. Patterson was hoping to call this new area Sibleyville, after an engineer and friend named James Sibley, who laid out the new town and finally gained peace in his life.

But the railroad wasn't finished. The personal secretary to C.P. Huntington, F.S. Douty, was directed to change the name of the new area to something more relevant. Greek culture was a popular topic at the time, and Douty was a scholar. So right before the official railroad timetable was published, Douty refiled the official town map and named the village on official records. The name he chose was a tribe of warrior people who for centuries fought ferociously for their land and their agrarian lifestyle, the Danubians. The name was either misspelled or intentionally changed to Dinuba, and the name stuck.

For years afterward, Patterson, Sibley, and other settlers tried to not align the name with the extremely warlike Danubians, as they did not want to keep reliving the Mussel Slough shooting, but the railroad had the last word.

One

BEGINNINGS

This is a photograph of nothing. Before water, irrigation, and the railroad, Dinuba was a blank slate. There were no irrigation canals, and not even a railroad spur. Had it not been for the Mussel Slough shooting, alkali poisoning in the soil, and an 1890 fire that devastated Traver, there never would have been a Dinuba. But the convergence of all these events made Dinuba a boomtown and left Traver just spot on the map with no town. (Author's collection.)

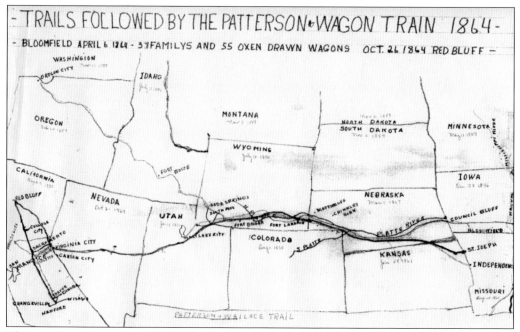

This was the map used in 1864 by the Patterson wagon train traveling from St. Joseph, Missouri, to Red Bluff, California. When they arrived, they found that all of the farmland had already been purchased. They heard there was great land to the south, so they moved on to Mussel Slough, in the Hanford-Grangeville area. (Doug Newton family.)

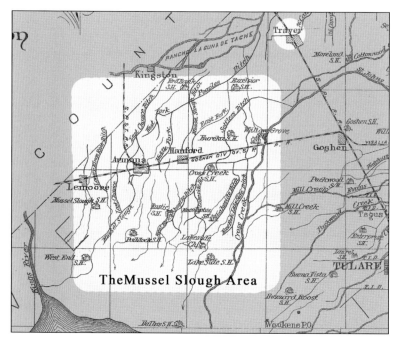

Shown in this map of the Mussel Slough area are all of the ditches that had been dug to irrigate the wheat being grown in the area. The knowledge of how to channel and divert the Kings River to irrigate the land for wheat production proved to be valuable to the beginning of Dinuba. (Author's collection.)

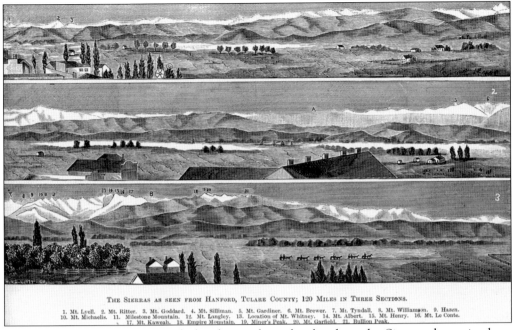

This is an etching of the Mussel Slough area from the slough to the Sierras, shown in three sections. The proximity to the Sierras and to the Kings and St. John Rivers, and the high price for a bag of flour, made wheat a rich, robust cash crop. By 1880, the Mussel Slough–Traver population exceeded that of all of Fresno County. (Author's collection.)

NAMES OF CANALS.	Wheat.	Barley.	Alfalfa.	Corn.	Beans.	Potatoes.	Vegetables.	Orchard.	Vineyard.	Forest.	Totals.
People's Ditch........	9,159	985	1,173	547	151½	47½	31	87	5	72	12,340
Mussel Slough........	1,270	255	56	75	4	4	3	1,685
Last Chance.........	6,798	2,133	2,330	282	142½	29	40	57	34	16	12,040
King's River	5,063	587	342	15	5	...	41	15	12	...	6,084
Rhodes' Ditch	1,058	240	371	65	1	8	22	10	...	1,775
Totals	23,348	4,200	4,272	984	299	81	124	184	61	88	33,924
Settlers' Ditch........	5,684	919	616	217	14	14	28	52	16	71	7,779
Lake Side	3,571	607	773	290	51	1	5	25	18	63	5,564
Totals	9,255	1,526	1,389	507	65	15	33	77	34	134	13,343
Grand Totals....	32,603	5,726	5,661	1,491	364	96	157	261	95	222	47,267

This is a production report from the Mussel Slough area recording wheat production along the various ditches. All of this wheat and other agricultural products were transported to the town of Traver for shipment to markets. In 1886, Traver shipped 32,214,517 pounds of wheat. In the first seven months of 1887, 34,407,100 pounds were shipped, exceeding any shipping point in the United States, with 30 million pounds still in the warehouses, a record that stands today. (Author's collection.)

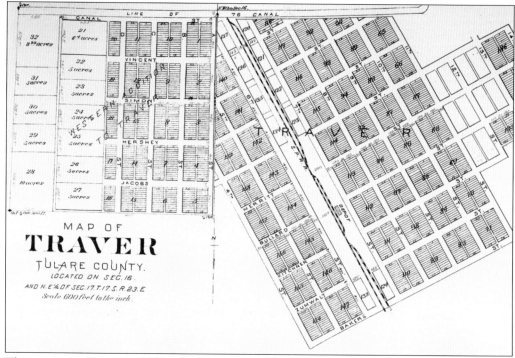

MAP OF

TRAVER

TULARE COUNTY.
LOCATED ON SEC. 16.
AND N.E ¼ OF SEC. 17, T.17, S.R.23.E
Scale 600 feet to the inch.

This is a map of Traver in 1890. Traver was the center of commerce for the western side of Tulare County and was a bustling, booming community. Shortly after this map was filed, the town burned almost completely to the ground. The only remaining buildings were moved, intact, to the new town of Dinuba. Today it is almost impossible to find even the foundations of any buildings at the former site of Traver. (Ron Parmenter.)

This c. 1870 tintype shows the Wilson brothers before they moved to California. California represented the land of opportunity for them and other families, especially after the end of the Civil War. (Olson family.)

12

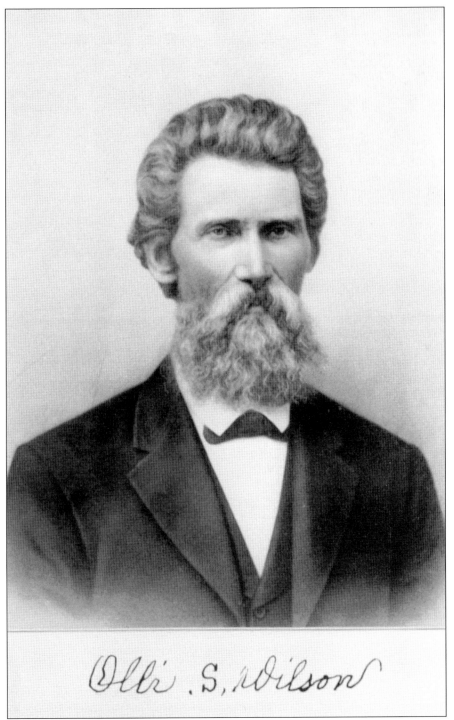

Ollie S. Wilson

Ollie Skeen Wilson is credited with being the first person to settle in the area that became Dinuba. The real problem in the area was the lack of water, but the Wilson farm had its own source. Ollie Wilson's original orange orchard is still located at Kamm and Crawford Avenues in Dinuba and is still producing oranges. (Alta Historical Society.)

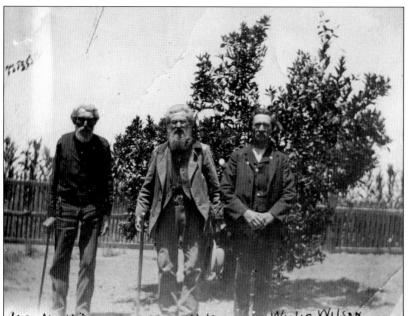

The three Wilson brothers are pictured at their home in California about 1900. From left to right are Ollie, Tobacco, and Wylie. The Wilson brothers founded one of the major families in the Dinuba area. (Olson family.)

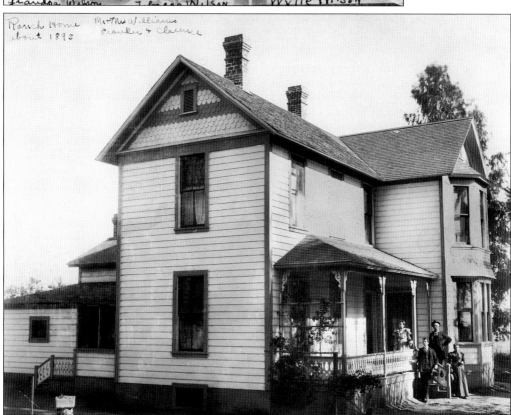

This is an example of incorrect history. In *History of Tulare County*, this house is depicted as the home of Ollie Wilson. The home is actually that of his son-in-law, Clarence Williams. The picture was taken about 1895. (Olson family.)

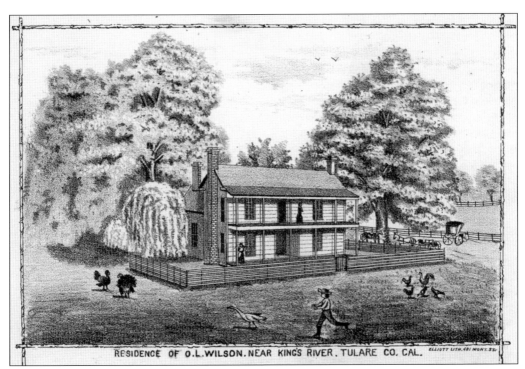

RESIDENCE OF O.L.WILSON.NEAR KING'S RIVER. TULARE CO. CAL.

This is a photograph of the home of O.L. Wilson in the 1880s. His nearest neighbors were Amaziah Clark and Robert Kennedy in what would become the German Mennonite Colony, west of Dinuba. (Olson family.)

Thomas Jefferson McQuiddy, a former Confederate cavalry major, was a very outspoken critic of the Southern Pacific Railroad. Major McQuiddy was one of the founders of the Grand Land League in Grangeville. Just prior to the Mussel Slough shooting, Major McQuiddy was said to be drilling troops on the streets of Hanford. For years after the Mussel Slough shooting, Major McQuiddy and Patterson traveled California giving public speeches against the railroad. Major McQuiddy's son John T. McQuiddy went on to be the first director of the Alta Irrigation District in Dinuba. (Alta Irrigation District.)

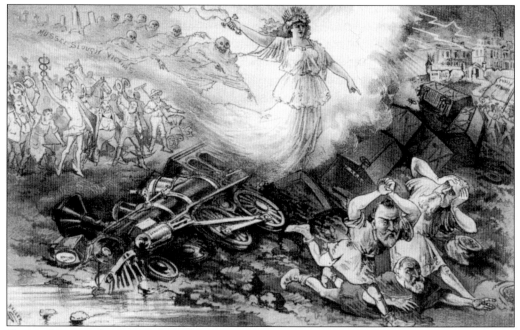

"Impending Retribution" is the title of this political drawing published on October 7, 1882, by Edward Keller in the *Wasp*, a widely circulated Republican magazine. It depicts an angel from heaven with a fiery sword descending upon the Big Four—Leland Stanford, C.P. Huntington, Mark Hopkins, and Charles Crocker—and wreaking retribution for their part in the Mussel Slough shooting. The Mussel Slough victims can be seen in the background. This is an example of the type of press coverage that helped to polarize California after the shooting. (Sacramento State Newspaper Archives.)

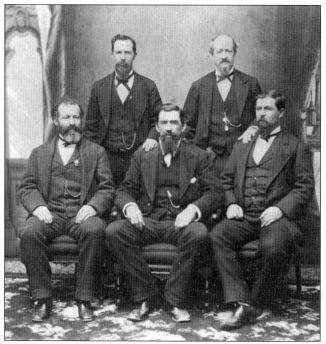

The Mussel Slough Five were, from left to right, John D. Purcell, James Patterson, William Braden, John J. Doyle, and Wayman L. Pryor. The five were arrested and charged with the murder of the seven dead victims. They were eventually convicted of assault on a federal officer and served only six months in the San Jose Hotel instead of the San Jose Jail. Upon appeal to the Federal Circuit Court of Appeals, they were freed immediately. Had it not been for this event, Dinuba might never have existed. (Tulare County Historical Society.)

James Patterson is probably the person most responsible for the founding of Dinuba. Patterson became the focus of the Mussel Slough shooting and the turmoil that followed. It was forever his wish to find a home where he could raise his family. His friend James Sibley first laid out the town. (Tulare County Historical Society.)

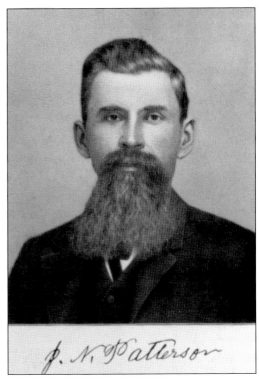

These were the stockholders of the Alta Irrigation District. The turning point in agriculture for Tulare County was when seven landowners formed the 76 Land and Water Company, which shortly after became the Alta Irrigation District, headquartered in Dinuba. They developed a 30,000-acre area south of the Kings River to provide adequate irrigation. The chief engineer was P.Y. Baker. Other stockholders were Charles Kitchener, Charles Traver, H.P. Merritt, D.K. Zumwalt, I.H. Jacobs, and Francis Bullard. (Alta Irrigation District.)

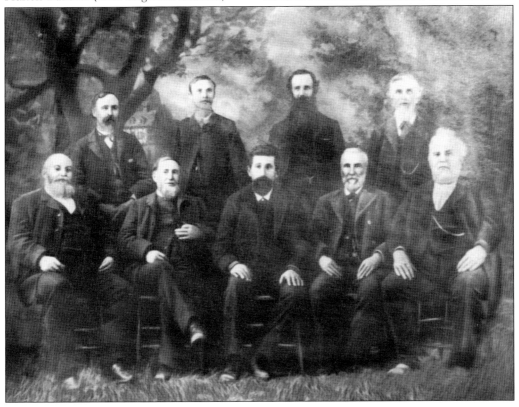

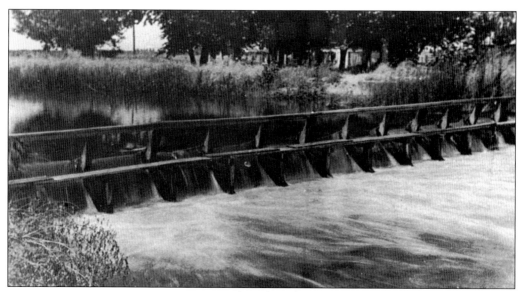

When the Alta Irrigation District was formed, ditches just like the ones in Mussel Slough were dug covering thousands of acres of previously dry farmland. This is an example of the early canals in the Dinuba area, this one at Reed Avenue and El Monte Way, west of Dinuba. (Alta Irrigation District.)

The Traver Advocate.

Issued every Wednesday afternoon.

F. V. DEWEY, Proprietor.

Office in Keller Building, southeast corner of Eighth and Merritt streets (opposite the Post office), Traver.

SUBSCRIPTION PRICE.

For one year, strictly in advance,........... $1 00
Single copies............................... 5 cts

SALUTATORY.

With this issue THE ADVOCATE makes its initial bow. The outfit is new and the paper starts in a new country. It proposes to advocate new improvements and the immigration of new people.

The proprietor did not come here for his health, but to make money, and recognizes the important fact that all goods have a value according to the fineness of the fabric and finish of the manufacture. Our aim will be to deserve support by an untiring effort in pushing the interests and development of Traver and the 76 country.

The paper will be independent in politics and will advocate men for office in whom we have full confidence.

THE ADVOCATE starts out with a liberal support, and we would remind its patrons that our interests are mutual—that a good paper reflects like a mirror the community behind it. Give us your hearty support and THE ADVOCATE will aid you in all laudable enterprises and grow with your growth.

The proprietor is married and has a family, and no utterance of this paper will ever cause a subscriber to regret that it has been introduced in the sacred circle of his home.

Let us go to work together and boom our country, and make Traver a city and the country surrounding it a thing of

The *Traver Advocate* supported the development of 76 Country, the common name for the land surrounding Traver and what was to become Dinuba. It was taken from the 76 Ranch, owned by the Tulare state senator and cattleman Thomas Fowler. (Author's collection.)

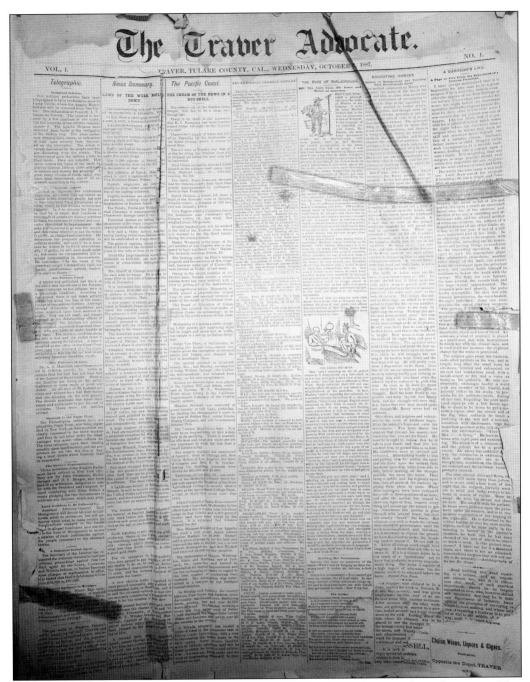

As the economy began to boom in Traver, there was a need for daily news about the region. This is a copy of the *Traver Advocate* from its first day of issue, October 19, 1887. This was not the first daily newspaper in the Traver area, but it was the one that survived. Published by F.V. Dewey, it eventually moved with everything else to Dinuba and became the *Dinuba Sentinel*, which is still published weekly. When the State of California gathered original copies of all newspapers for microfilming, the *Traver Advocate* was missed. There is only a single copy of the first years of publication of the *Traver Advocate*, in the collection of Bob Raison of Dinuba. (Bob Raison.)

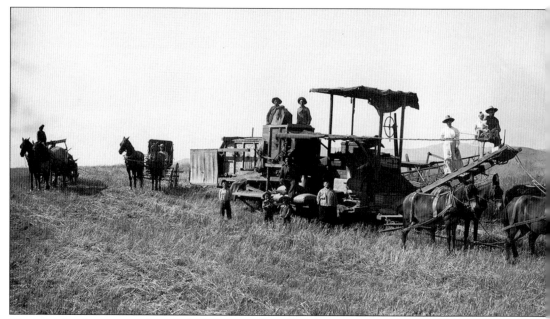

The initial cash crop raised around 76 Country (later Dinuba) was wheat, harvested by machines pulled and powered by teams of up to 40 mules. These harvesters were a common sight in August and September every year as millions of tons of wheat were harvested and shipped east. Every

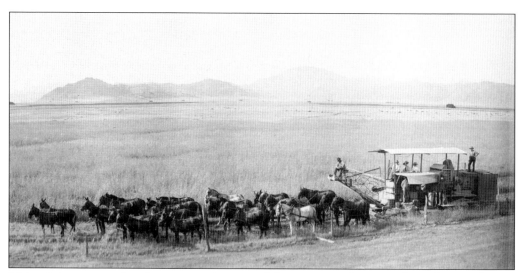

Maintaining teams of mules was a major part of the expense of raising wheat. During August and September in the Dinuba area, temperatures could reach well in excess of 100 degrees for extended periods; animal mortality was a major problem. Wherever a harvester was working, a water wagon would not be far away, but at times, no matter how much water was given to mules, animal loss was still an issue. (Author's collection.)

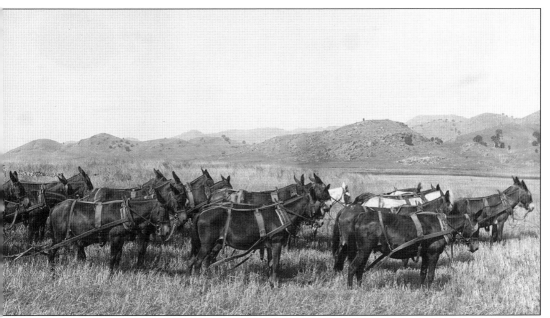

year, harvesters became more complex and larger. The Traver-Dinuba area holds more agricultural patents than any other area in the United States. (Author's collection.)

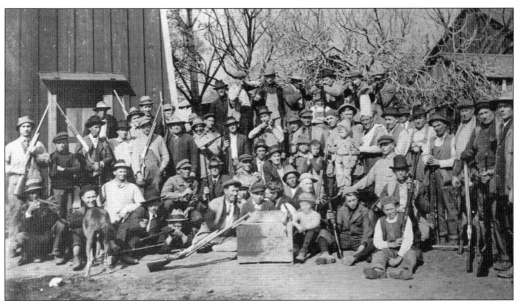

Another risk to wheat farmers was the ever-present jackrabbit, which found wheat fields a perfect home and multiplied to incredible numbers. Rabbit burrows in wheat fields would cause broken legs in mules. In an attempt to eliminate this problem, Tulare County organized annual jackrabbit drives, like this one in the late 1890s. The county would set up a V-shaped corral about seven miles long, and about 200 horsemen along with 300 to 600 men on foot would drive the rabbits across the county to the corral in Traver, there to be shot, typically killing 6,000 to 10,000 rabbits. Although this may be considered cruel, farmers considered jackrabbits the worst nuisances of the valleys in California. (Author's collection.)

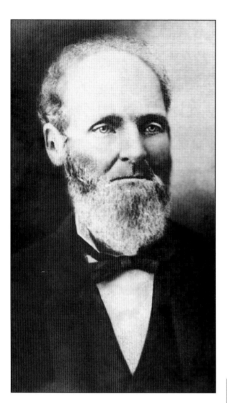

James Sibley, born in New York in 1839, came to Mussel Slough in 1870 with his wife's three brothers, Reed, Edward, and C.F Giddings. Sibley married Susan Giddings, the sister of his partner. Following the Mussel Slough shooting, Sibley moved to Dinuba in 1884. (Alta Historical Society.)

Sibley was a trained civil engineer, and he surveyed much of the Alta Irrigation District's holdings. Sibley bought and sold a great deal of land in the Mussel Slough and Dinuba areas and is credited by some as the founder of Dinuba, though county records do not reflect Sibley founding the town. Popular lore has the town originally being called Sibleyville, but the first train schedule on a map filed a few days before the auction for lots listed the name as Dinuba. If the town was ever known as Sibleyville, it was only for a few days and only to a few people. The only newspaper account of Sibleyville is a single small ad in the *Fresno Republican* for land sales. (Ron Parmenter.)

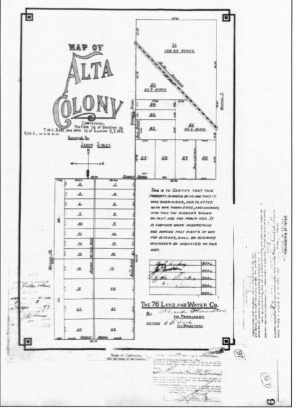

The only unique map filed by James Sibley with Tulare County is for the Alta Colony, a property west of Dinuba owned by the 76 Land and Water Company, the predecessor to the Alta Irrigation District. (Ron Parmenter.)

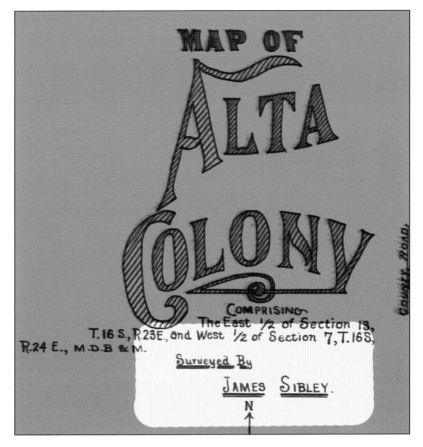

On March 17, 1888, Adolf Lewis and Henry Jerusalem sold their portion of Section 17 to the Pacific Improvement Company as part of the new town of Dinuba. Three weeks later, Sibley and J.D. Tuxbury's sale followed suit with this deed dated April 13, 1888, also selling to the Pacific Improvement Company, a subsidiary of the Southern Pacific Railroad. Contrary to common belief, Sibley did not donate the property for Dinuba to the railroad but sold it for an undisclosed amount. (Author's collection.)

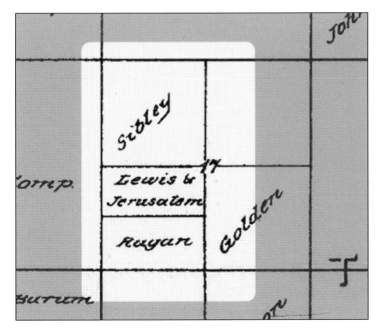

None of these sales were filed until November 9, 1888, the same day the plat map drawn by I.D. Norton was filed. Norton actually surveyed the town in May 1888, but the map was held back until the sales were filed. These portions of Section 17 became the basis for Dinuba. The formation of Dinuba was the beginning of the end for the Mussel Slough/Traver boom town. In December 1888, both the *Traver Advocate* and the *Visalia Times Delta* reported the new town as Dinuba. (Ron Parmenter.)

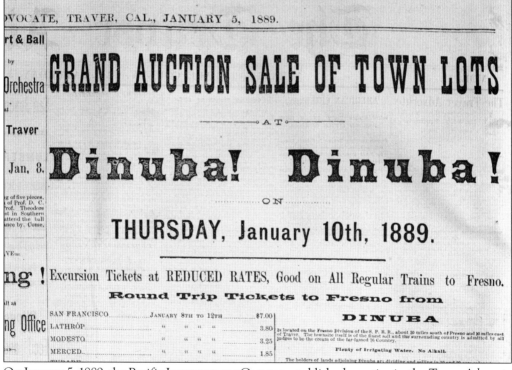

On January 5, 1889, the Pacific Improvement Company published a notice in the *Traver Advocate* to auction Dinuba lots, offering special excursion tickets from San Francisco. Auctions were held on January 10 and conducted by J.M. Shannon and F.S. Douty, secretary to C.P. Huntington of the Southern Pacific Railroad. This was an unusual means to start a town, as there were no settlers yet. However, selling the lots was big news. It represented an official blessing by the railroad that the Mussel Slough Tragedy was over. (Author's collection.)

Two

AGRICULTURE

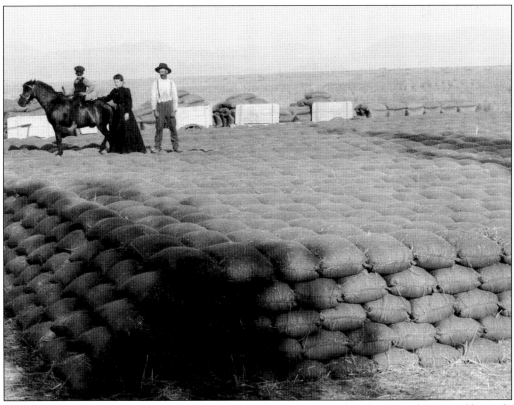

For the first few years of Dinuba's life, wheat was the cash crop. The wheat was harvested by mule power, then thrashed and bagged for storage and shipment. The low moisture content of this wheat made it prized over wheat from the Midwest, as it could be stored without risk of molding. This photograph was taken by Louis Mitchell about 1895. (Author's collection.)

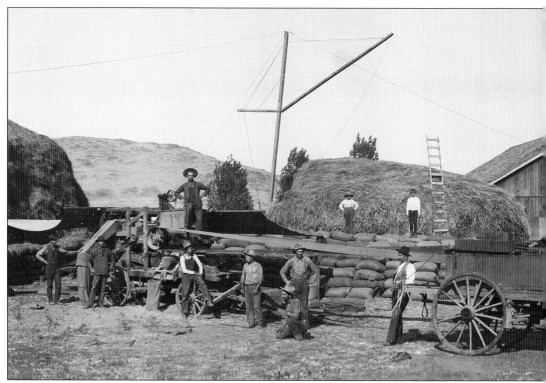

By the 1890s, the production of wheat had become mechanized, with centralized thrashing machines run by steam. Notice the number of men involved to produce one bushel of wheat,

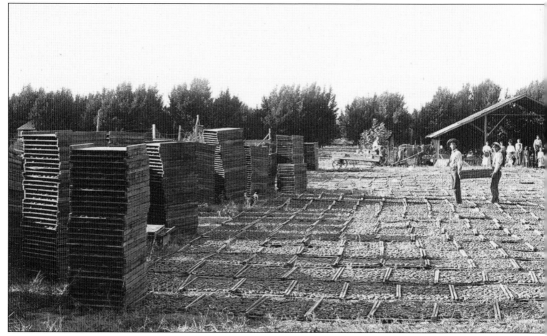

By the mid-1890s, there was a search for other crops. A market for dried fruit was discovered, as it could be shipped back East without spoilage. Drying peaches became a big business. Though it

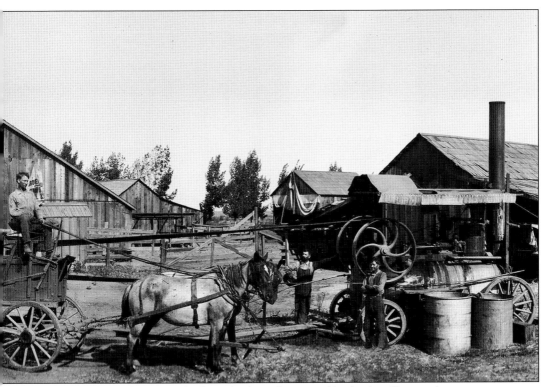

which would have been worth about $1.50 at the time. (Author's collection.)

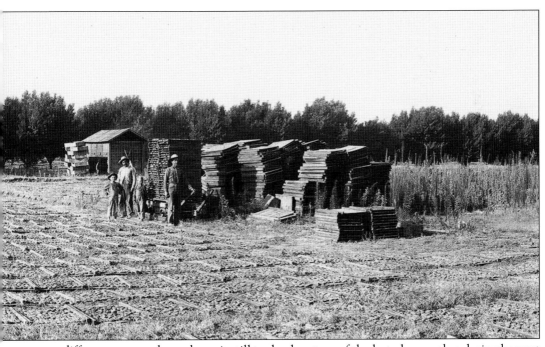

was a different process than wheat, it still took advantage of the hot, dry weather during harvest time. (Author's collection.)

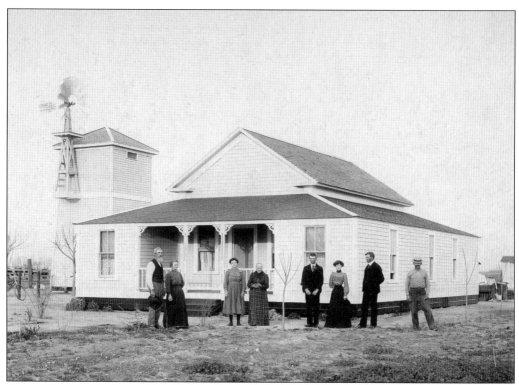

Pictured here is the James Patterson family in the 1890s. From left to right are James Patterson, his wife Ann Patterson, unidentified, Lizzie Patterson, ? Burge, Arthur Thayer, Joyce Coates, Clarence Patterson, and Will Patterson. (Newton family.)

Bart Patterson is on the right, picking peaches around 1910. Very few farm owners were gentlemen of leisure. Most had to work the land alongside their families and hired hands. (Newton family.)

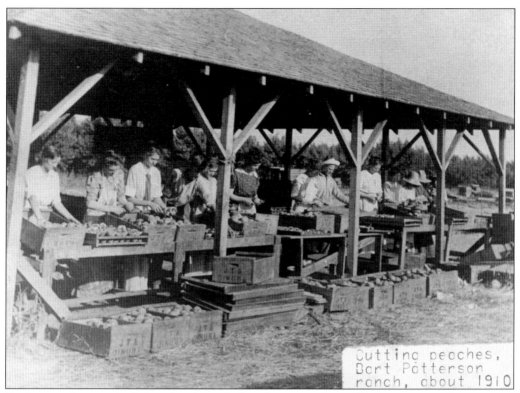

Cutting peaches,
Bart Patterson
ranch, about 1910

Drying peaches required that they be picked and cut into slices. Workers are seen here cutting peaches on Bart Patterson's ranch. Bart was the son of James Patterson. This was grueling work in heat that would reach 110 degrees. (Alta Historic Society.)

This clipping of an article from the *Alta Advocate* suggests that perhaps grapes that are going to rot could be turned into raisins. In 1876, William Thompson introduced Lady deCoverly seedless grapes from his home in England. In 1880, Thompson grapes were planted in the San Joaquin Valley. It would only be a few years before the value of Thompson raisins was realized. (Author's collection.)

THERE are thousands of vines of Mission grapes in this valley on which the fruit every summer is allowed to dry or rot. These ▮▮▮ should be grafted to some variety of raisin grapes, the product of which, if the producer does not care to prepare it for market himself, could be taken to the driers and remunerative prices received for it. There will undoubtedly in the future be driers enough in Tulare county to handle all the grapes that can be produced, and the market for good raisins is unlimited.

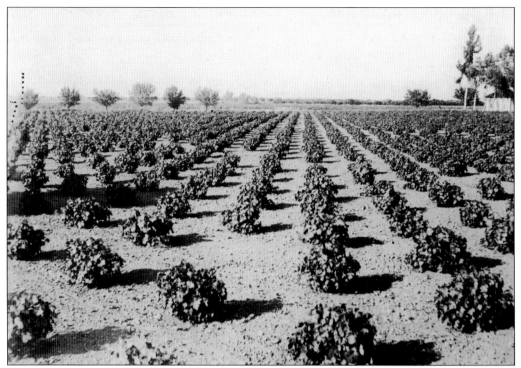

This is a planting of Thompson grapes in the 1890s. Notice that they are not staked up from the ground. It would be a few years before the University of California Agricultural Extension would suggest to growers that the yield could be much improved if the grapes were not on the ground. (Author's collection.)

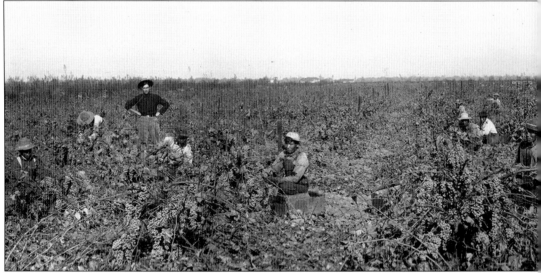

Pictured here is a grape ranch during harvest around 1913. Notice the foremen and the Asian pickers. According to Marn J. Cha's *Koreans in Central California*, in 1903, Koreans flocked to Hawaii to work in the sugarcane fields. In 1910, Japan annexed Korea, and the Koreans in Hawaii were required to swear loyalty to the emperor of Japan. Refusing to do this left about 3,000 Koreans personas non grata, having no legal passport. Most of them immigrated to California, pretending

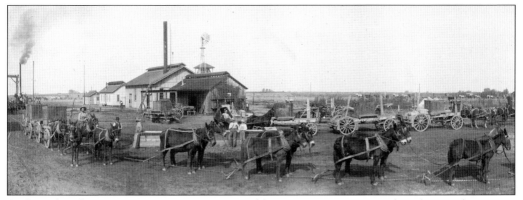

At first, the Thompson grapes were grown as table grapes, as many are today, along with emperor seeded grapes. Bins of grapes were picked and hauled by mule team to a centralized location for shipment. (Author's collection.)

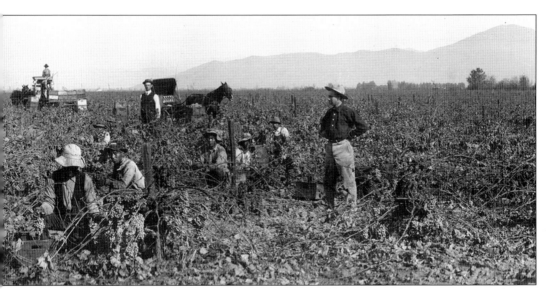

to be Chinese. Dinuba eventually became home to several hundred of this immigrant population. Settling in a part of Dinuba known as China Town, these Koreans were confused with Chinese in the area. This photograph by Louis Mitchell is one of the earliest sources of proof of Koreans in Dinuba. (Author's collection.)

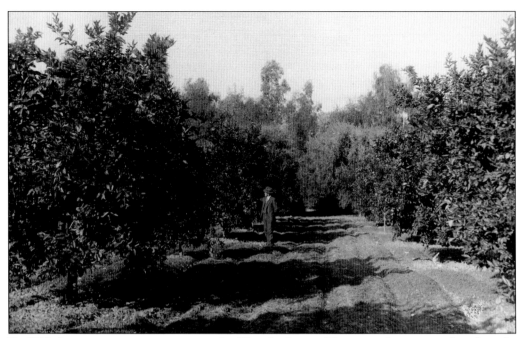

By 1900, farmers were experimenting with all kinds of crops. They were discovering that the rich, sandy loam soil and good water from the Alta Irrigation District would grow almost anything. Citrus became a major crop on Dinuba's east side, and large orange groves sprang up. Eventually, Sunkist had a major packing facility here, and the new town of Orange Cove sprang up. (Alta Historical Society.)

Pictured is a Best Manufacturing Model 1903 steam tractor. Manufactured in San Leandro, California, it is thought to be the first steam tractor in Tulare County, on a farm at the foot

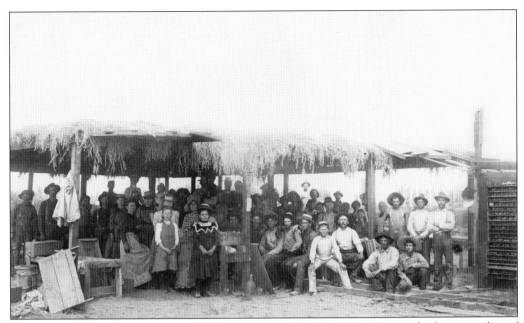

This is the Patterson fruit drying shed as it appeared by the 1910s. Notice the large number of children in the work crew alongside men and women. In those days, everyone worked at harvest time, often staying out of school. (Author's collection.)

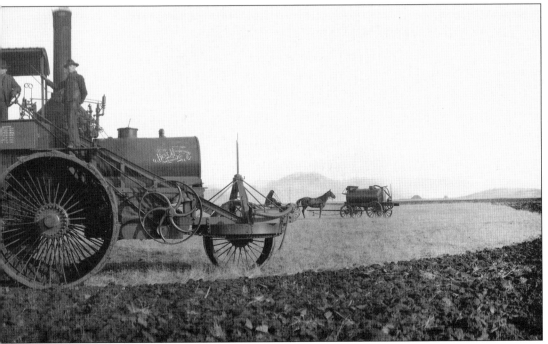

of Mount Bald near American and Crawford Avenues. This is the same farm seen in the mule harvester photographs earlier in this book. (Author's collection.)

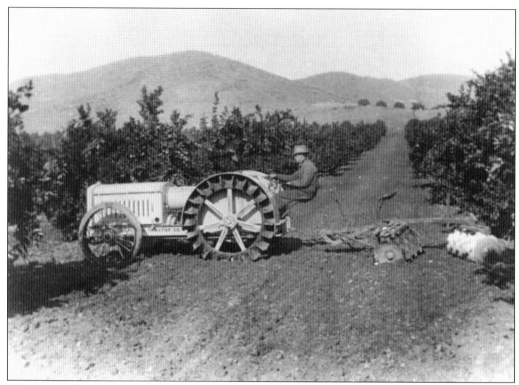

The Moore farm and an Interstate tractor are seen here around 1915. The Interstate Tractor Company disappeared in 1920. Notice that the tractor is pulling a disc plow made to be pulled by a horse. There is a seat on the plow. (Wooley-Moore family.)

By 1920, Dinuba was home to a wide range of fruit and produce, and it was possible to grow almost anything. The water provided by the Alta Irrigation District and the perfect growing conditions

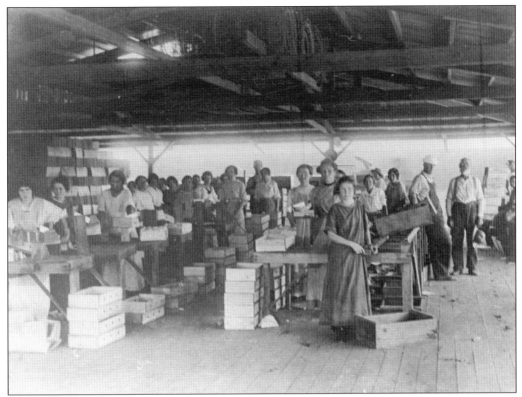

Fruit packing and shipping was a growing business with the advent of the ventilated refrigerator railcar, which made it possible to ship fresh fruit to areas on the West Coast from the San Joaquin Valley. One of the earliest packinghouses is pictured here in 1910. (Barbara Richardson.)

made for an agricultural gold mine. (Author's collection.)

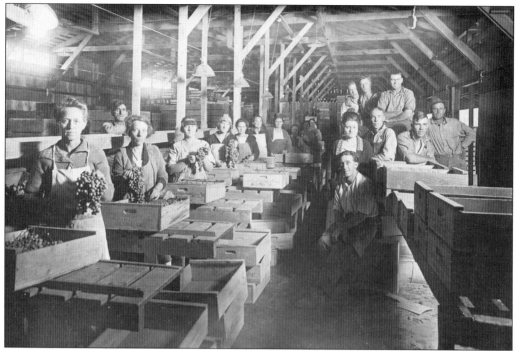

Packinghouses started springing up in Tulare County in and around Dinuba, dealing in table grapes. This is the Sultana Fruit Company, just east of Dinuba. (Barbara Richardson.)

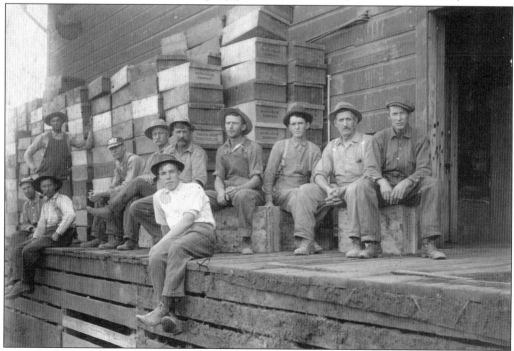

The Associated Warehouse Company was a subsidiary of Sun Maid Raisins, which was at its peak in 1923. Raisins were an ideal crop, requiring little water, using the natural fall heat to dry, and perfect to ship. Seated in front is Henry Walther. (Barbara Richardson.)

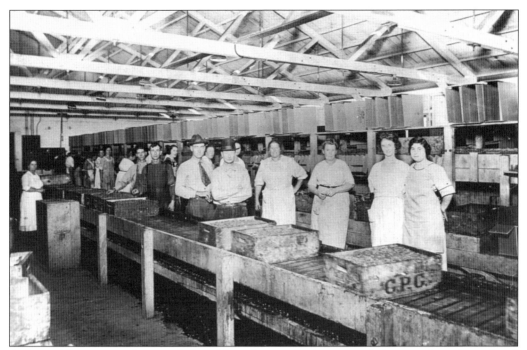

As fruit packing grew, it became sheltered from the outside elements and almost exclusively employed women. This photograph of a packing operation was taken in 1920. (Alta Historical Society.)

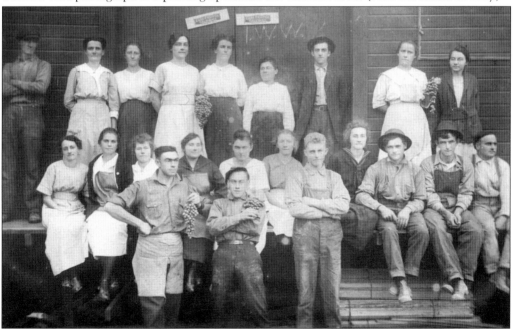

In 1910, the US Supreme Court forced Armour & Company and other meatpackers to divest their monopoly on refrigerated railcars and enabled companies to ship fresh food from California to the East Coast. The Earl Fruit Company, pictured in one of its packinghouses in 1920, was purchased by the DiGiorgio Company in 1911, making one of the largest produce companies in the United States. (Alta Historical Society.)

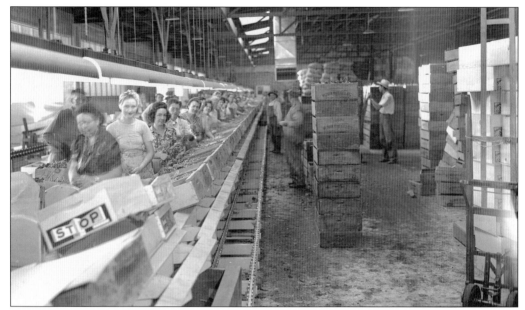

Wileman Brothers & Elliott was one of the first packing companies to use branding on its products. Seen here is the Stop brand of emperor grapes, a large purple grape that gave its name to the Dinuba High School sports teams. In 1948, Walter Goldschmidt of the US Department of Agriculture issued a report entitled "The Dinuba-Arvin Controversy." Goldschmidt found that Arvin, a small town north of Bakersfield with similar soil, water, and climate to Dinuba, suffered economically but had one major agricultural employer, the DiGiorgio Company, while Dinuba prospered economically with many small farms and smaller packinghouses. Goldschmidt's premise was eventually discredited but later re-examined and found to be correct. (Barbara Richardson.)

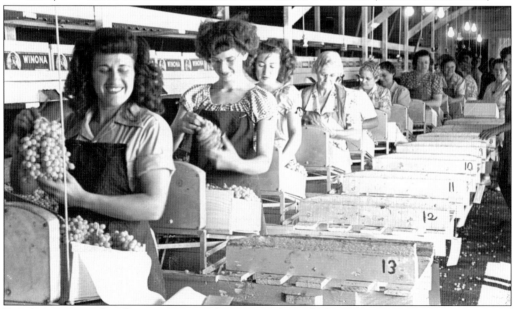

Dinuba's many packinghouses continued to prosper through the 1940s, 1950s, and 1960s. George Zarounian's packinghouse was one of them. Pictured here from the left are family members Alice and Gladys Zarounian, Sarah Collins, and Sarah Cox. (Martzen Studio.)

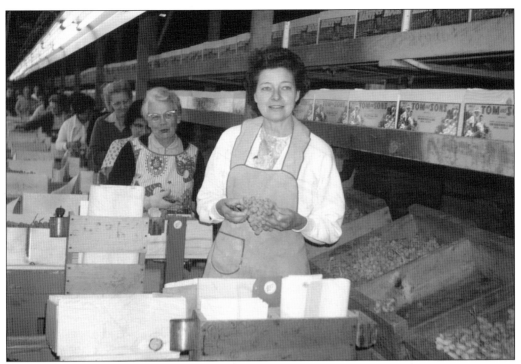

Tom and Sons packinghouse, pictured here in 1967, shows that the Thompson grape packing business changed very little in 70 years. It still primarily employed women standing on their feet for many hours. (Newton family.)

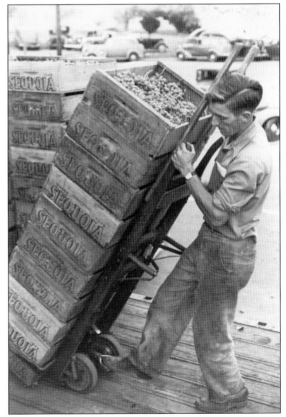

Crews are moving crates of grapes at Sequoia Packinghouse in the 1960s. This was a tough job that employed many high school–aged and other young men during the harvest season. (Martzen Studio.)

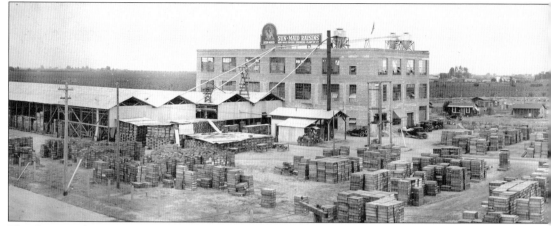

The Sun Maid Raisin plant in Dinuba is pictured in 1920, showing the sheer size of the raisin business by that time. The photograph was taken from the north side of the plant. Notice to the

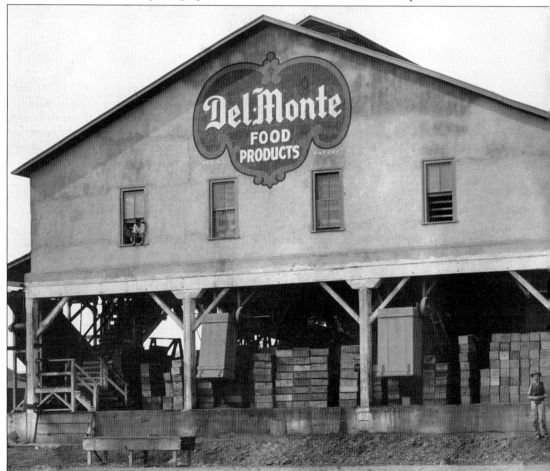

Del Monte Foods was only one of the national brands with a large canning and packing operation in Dinuba, employing over 100 workers. Founded in 1888, the company began operating as CalPac (CPC) in 1916, which is the name on the ends of the crates in this c. 1920 photograph.

right the "Tortilla Flats" part of town, which had also been known as China Town and German Town. (Alta Historical Society.)

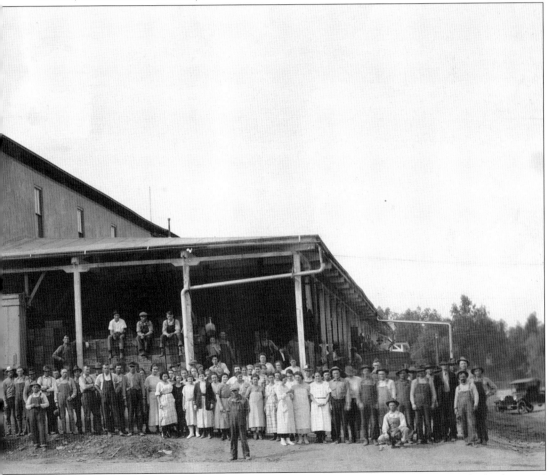

Del Monte went on to annual sales of over $1.8 billion. Notice the Model T in the background at far right. (Alta Historical Society.)

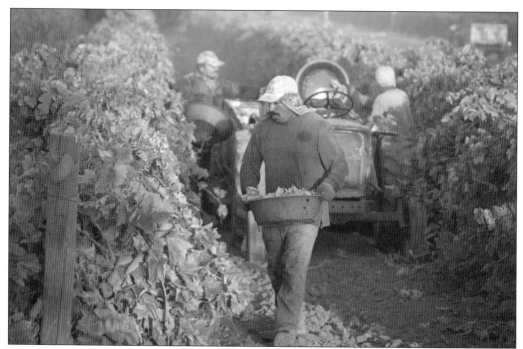

Picking grapes has not changed much in the last 100 years. The fruit is still picked by hand, but now the vines are staked up to keep the grapes off the ground. This photograph is from 2004. (Author's collection.)

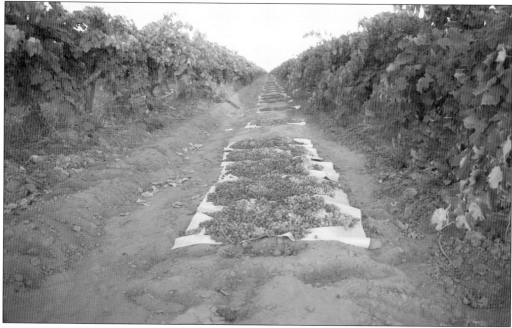

Drying grapes for raisins is still done primarily by the sun. Instead of wooden trays, sheets of paper are used. But grapes still have to be turned halfway through the drying process. Many high school students have worked turning trays, a hot, smelly, and dirty job. This photograph is also from 2004. (Author's collection.)

Three

BUSINESS

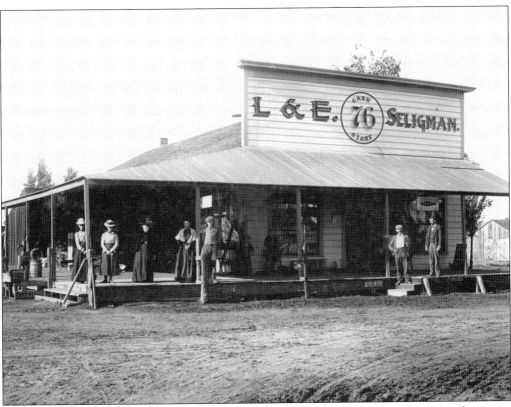

The Seligman Brothers store is seen here around 1895. Note the "76" on the store, in reference to 76 Country, the common name for the area around Dinuba, the 76 Ranch, and the 76 Land and Water Company, the precursor to the Alta Irrigation District. Seligman's occupied what would become the Roachdale Company on South L Street at Kern Street. (Alta Historical Society.)

Dinuba Rochdale Co., Inc.

————Dealers in————

Fancy and Staple Groceries, Flour and Feed, Hardware, Graniteware,
Dishes, Dry Goods, Notions, Gents Furnishings and Shoes

This is a Co-operative store Owned and Controlled by its Members. Are you a member?

M *W. Bolinger*

Dinuba

Phone Main 51
Dinuba, California

All bills must be paid by the 10th of each month. Statement of your account for *Dec.* 1918

DATE			DEBIT	CREDIT
		Bal	39 70	39 70
12 ·	4	Silk thread 15	15	
	6	spuds 50 banos 3 yello 10 salmon 35	1 25	
		w. nuts 40 slt pork 75 meal 85	2 00	
	10	gal oil 15	15	
	12	gingham	1 50	
	14	sugar 100 sal 40 polish lt apples 125	3 85	
		hose	40	
	17	chips bacon 90 beans 50	1 50	
		Cr by hose		40
	23	sw spds al smear sal 40 corn 35	1 75	
		ribbon	70	
	28	filling	15	
			12 40	40
			40	
		Paid Bal	12 00	

Paid 1-17-19

Wona

This is a bill for a monthly account at the Roachdale store in December 1918. Notice that it is a co-operative store, owned and controlled by its members. (Vetter family.)

44

Pictured is the D. Dickey and Sons General Merchandise Store in 1898. This was Dickey's first store. He was one of the first city trustees (now councilmen) and had the only location with a water supply when the 1901 fire almost destroyed the town. (Alta Historical Society.)

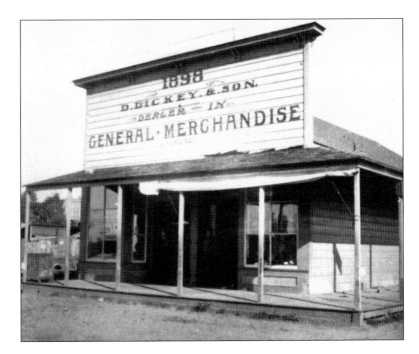

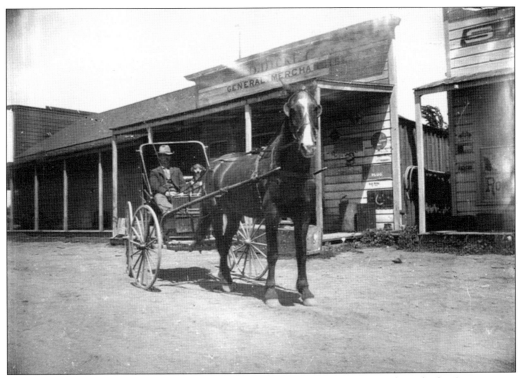

This is Dickey's expanded store around 1900. The store was on the north end of L Street, near White's Wagon Wheel shop. (Alta Historical Society.)

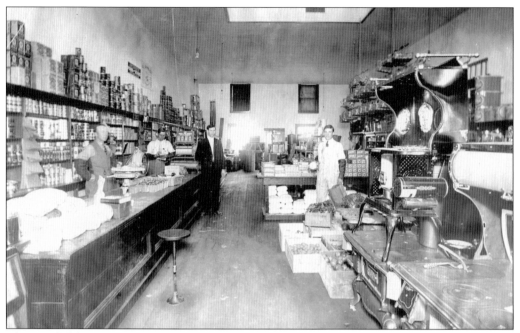

The Roachdale store sold a little of everything, and if they did not have it, they would get it. Note the wood-burning stoves in the foreground. (Alta Historical Society.)

White's Wagon Wheel shop was on the corner of North L and Fresno Streets. Coincidently, that location became a series of automobile dealers in later years, and is now the Tulare County Vocational Center. (Author's collection.)

This is a c. 1920 photograph of Dickey's last store. It is built of brick and not wood, and there is no name over the store. One of Dinuba's most important stores in the early days, Dickey's had ceased to do business by the 1940s. (Alta Historical Society.)

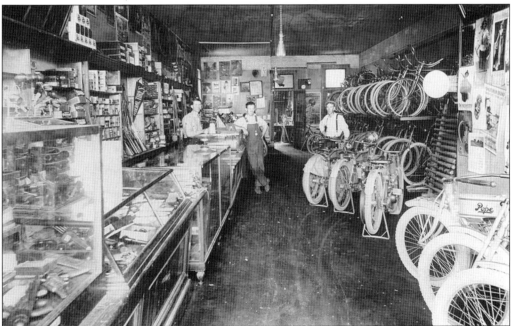

Pictured is the interior of the Woodhouse Cyclery. Note the Pope and Excelsior motorcycles on display. John Woodhouse was also one of the early town trustees. After the 1901 fire, the store was rebuilt on the east side of South L Street and remained there until it closed. Today it is a Western Union office, and the tin ceiling is still in place. (Alta Historical Society.)

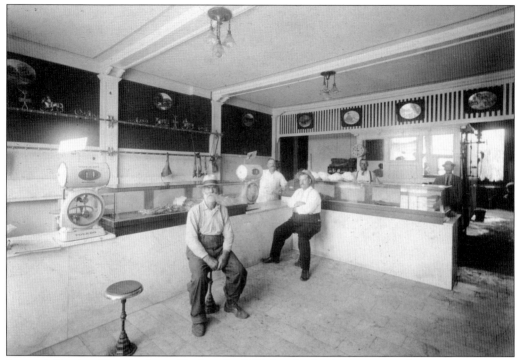

Iverson's Butcher Shop is pictured before the 1901 fire. In the days prior to refrigeration, the meat was in a display case or hanging in the store. This location was later occupied by the Woodhouse Cyclery and is today the Western Union office. (Alta Historical Society.)

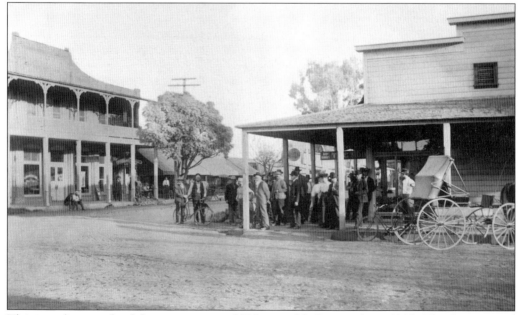

This is a photograph of the intersection of Tulare and L Streets about 1900. The Commercial Hotel is across L Street. It burned down in the 1901 fire and was replaced by the Barbis Hotel and Maryland Café. The dry goods store on the right became the First National Bank of Dinuba. (Alta Historical Society.)

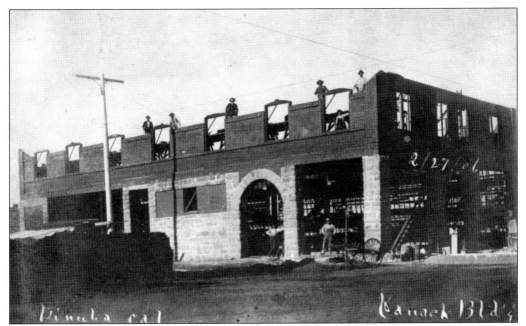

The Karnak Building is under construction in February 1906 on the corner of Tulare and L Streets. George W. Wyllie constructed the Karnak Building of several types of stone, making it very elaborate. Notice the corner post in the right foreground. This was later moved to permit a door in the corner of the building. The name "Karnak" was taken from a complex of ancient Egyptian temples. (Jack Hickman.)

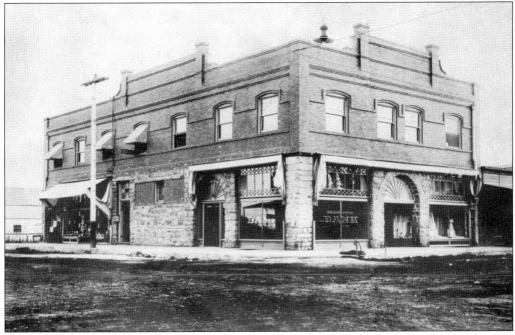

The Karnak Building was first constructed as Burum's Department Store. George Wyllie was a major shareholder and president of the United States National Bank for several years. (Alta Historical Society.)

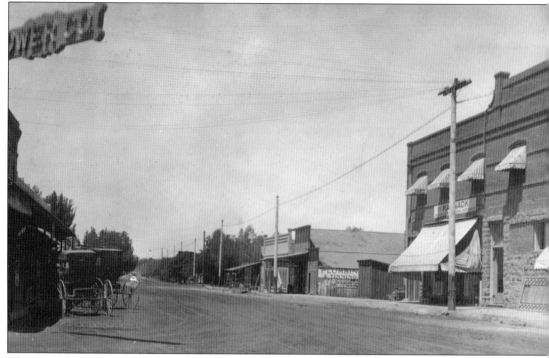

The Karnak Building later became the United States National Bank, then the Bank of America, and finally Conklin's store. When this photograph was taken the doorway has been moved to

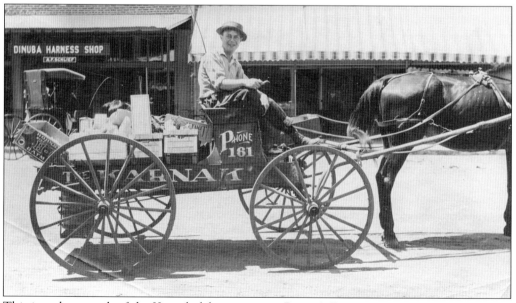

This is a photograph of the Karnak delivery wagon. Burum's Department Store was the largest department store in this part of the San Joaquin Valley. Free delivery was part of the service. The store was very successful, and the Burum family prospered. (Alta Historical Society.)

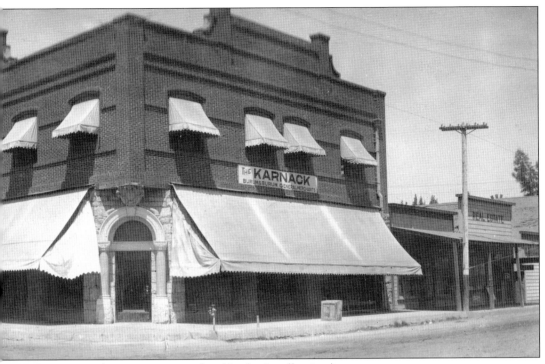

the corner, where it remains today. (Author's collection.)

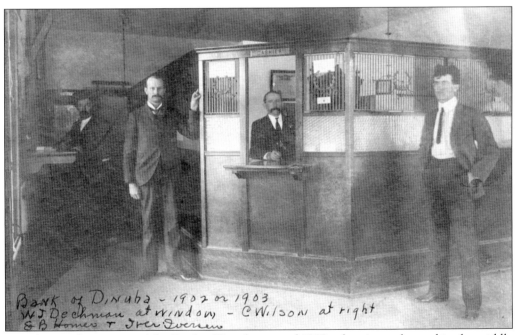

Bank of Dinuba - 1902 or 1903
W.J. Dechman at window - C. Wilson at right
E. B. Homes & Iver Iversen

Seen here is the interior of the Bank of Dinuba around 1902, when it was located in the middle block of South L Street. Pictured from left to right are E.B. Holmer, Iver Iversen, W.J. Dechman, and Clarence Wilson. The Bank of Dinuba was instrumental in providing loans and banking services to rebuild the town after the 1901 fire. (Olson family.)

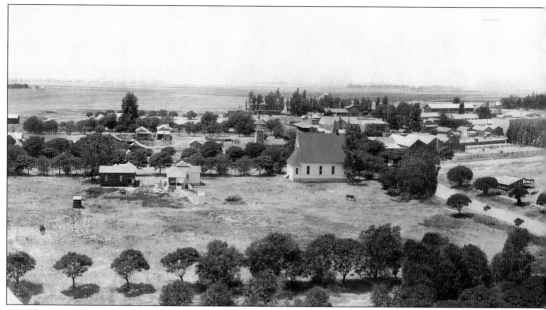

Dinuba is pictured here in 1903 from the top of the Dinuba School, where the Dinuba High School auditorium now sits. The population at the time was about 90. The near intersection is the location of Dopkins Funeral Chapel. Kern Street runs from the lower right to middle left as

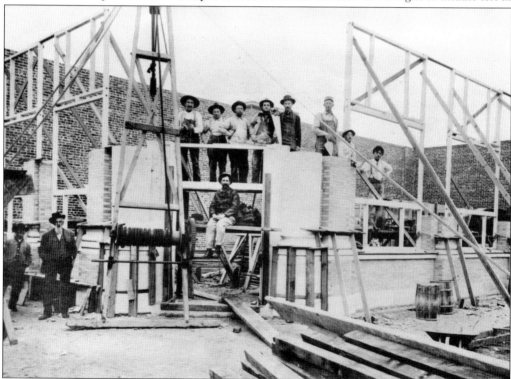

The construction of the First National Bank of Dinuba is pictured in 1907. It was the successor to the Bank of Dinuba. The bank was built on the corner of Tulare and L Streets opposite the United States National Bank. (Alta Historical Society.)

a dirt path. The white church at left center is the First Baptist Church. The buildings that run from left to right are along L Street. (Alta Historical Society.)

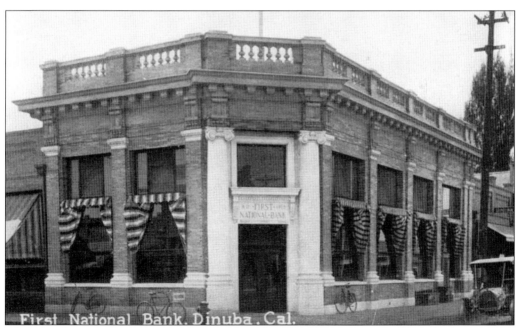

First National Bank, Dinuba, Cal.

This is a photograph of the First National Bank of Dinuba about 1915, around July 4. By the 1950s, this had become Security First National Bank, kitty-corner from the Bank of America. (Jeff Belknap.)

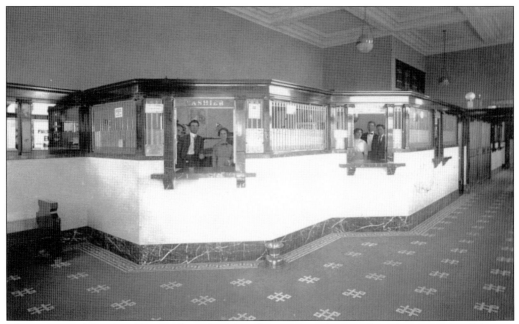

The interior of the First National Bank of Dinuba is pictured around 1915. Notice the elaborate finish work, made to compete with the United States National Bank on the opposite corner. (Jim Hickman.)

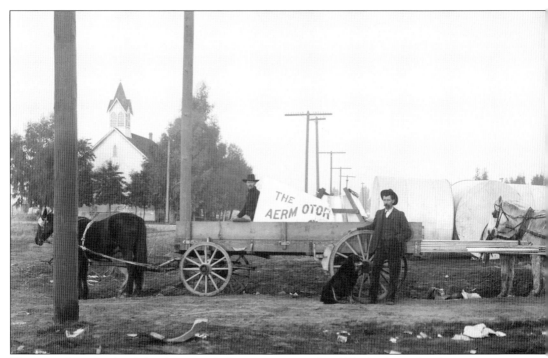

This is a photograph of the Aeromotor Company a couple of blocks from the downtown area as workers load up to drill and install a windmill water pump. Notice the church steeple in the

Pictured is the Barbis Hotel around 1907. There is a telephone exchange sign at lower right and the roads are unpaved. (Alta Historical Society.)

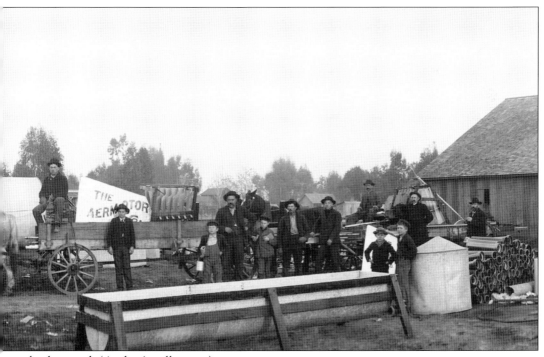

background. (Author's collection.)

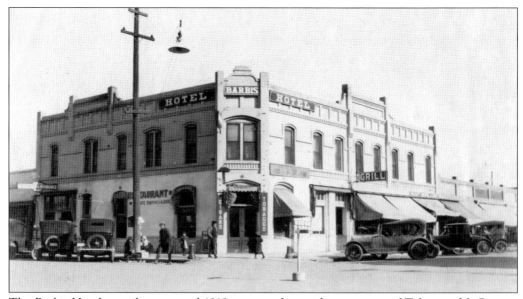

The Barbis Hotel, seen here around 1918, was on the southeast corner of Tulare and L Streets. This building became one of the four historical buildings on the four corners of Tulare and L Streets. (Alta Historical Society.)

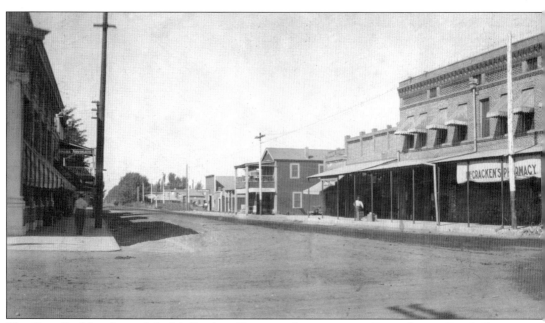

The Gusti Building housed the McCracken Pharmacy for many years. It now houses Don's Shoes. Next door to the left is the *Dinuba Sentinel*, which was previously the *Traver Advocate*. Across the street on the left side is the *Dinuba Advocate*, which eventually became the *Alta Advocate*.

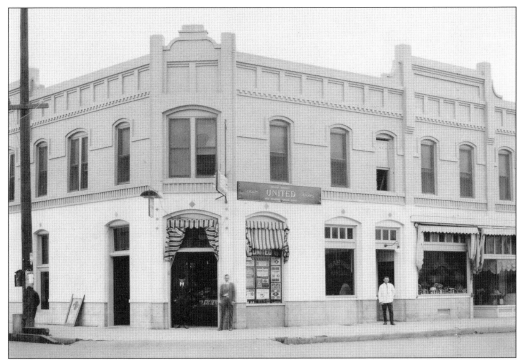

This is a c. 1930 photograph of the Barbis Grill. The upper floor is in disrepair, and the hotel portion of the building is no longer operating. This was the location of the Maryland Café until a fire on May 30, 1963. The building was torn down less than a month later and was a vacant lot for several years until the Rabo Bank was built in the 1990s. (Alta Historical Society.)

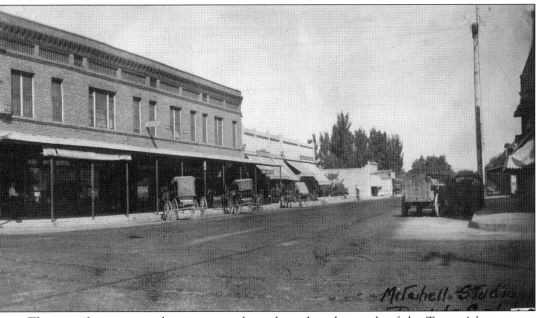

These confusing name changes came about through a clever sale of the *Traver Advocate* to a new publisher and the opening of the *Sentinel* across the street, so the town ended up with two newspapers. (*Dinuba Sentinel*.)

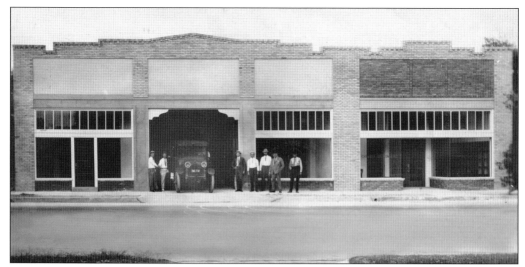

The building on North L Street north of Fresno Street is pictured around 1920. It was originally the Wells Fargo Stage Depot, then it became the Auto Stage Depot, then Randolph's Garage. The office to the right is the chamber of commerce, which had moved from Tulare Street. (Alta Historical Society.)

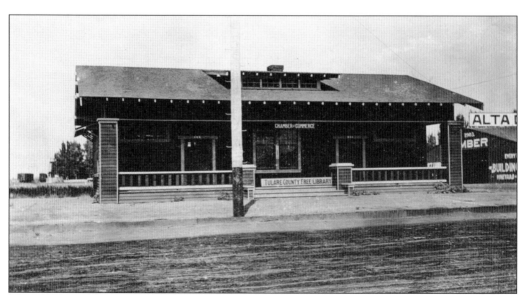

The original chamber of commerce on Tulare Street is seen here around 1914. The building also housed the Tulare County Free Library prior to the Dinuba Library being built in City Central Park. (Alta Historical Society.)

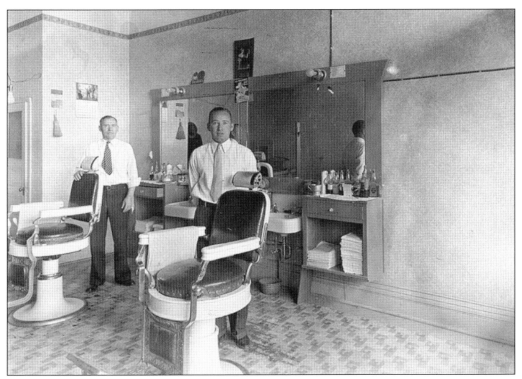

Maxwell's Barbershop on Tulare Street, seen here around 1920, was one of three barbershops in town. (Jeff Belknap.)

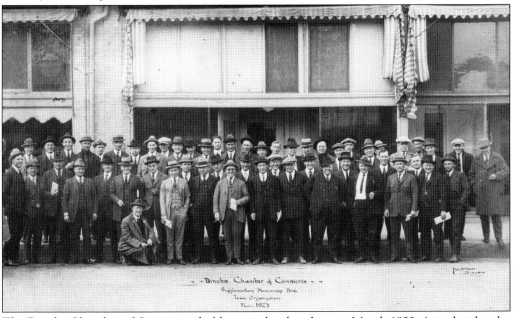

The Dinuba Chamber of Commerce holds a membership drive in March 1923. At its height, the chamber membership filled the high school auditorium. When the city voted to incorporate, there were 145 voters. In barely four years, the population had expanded to 930. By 1924, the population had grown to 4,000. (Author's collection.)

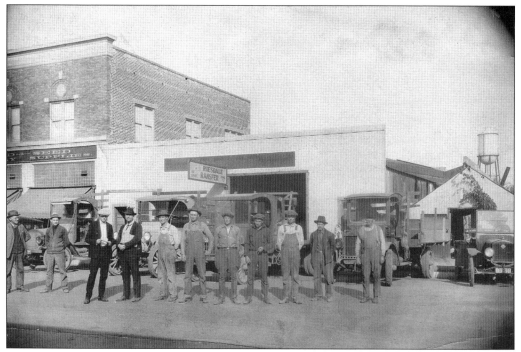

The Great Depression hit Dinuba very hard. It followed on the collapse of the price of raisins when Prohibition was enacted. Wine makers could not sell their grapes, so they started making raisins, flooding the market. Dinuba saw its population fall by 50 percent as the boom finally ended. With jobs in short supply already, the Depression was a near fatal blow. The city defaulted on many of its bonds and for many years had no credit. Seen here is a line of men looking for work in front of the Dinuba Feed and Seed and Rusedale Transfer. (Jeff Belknap.)

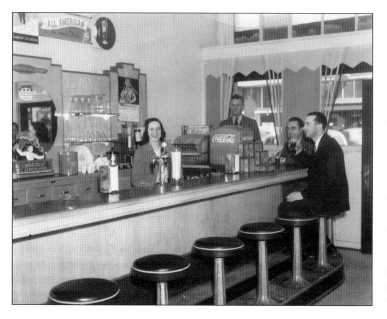

This is a c. 1940 photograph of the interior of McCracken's Pharmacy on Tulare and L Streets. The soda fountain was a popular place for businessmen to gather during the day. An ice cream soda was only 15¢, and Coca-Cola was blended from syrup and carbonated water. (Martzen Studio.)

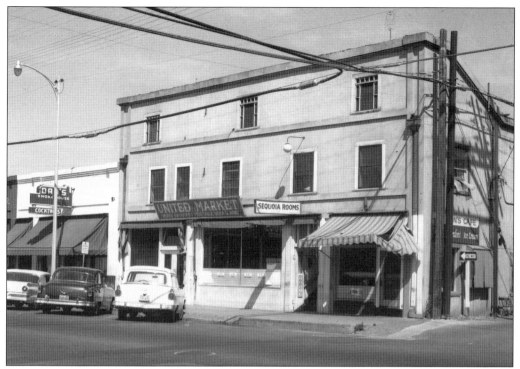

The original United Market is pictured around 1955 on Tulare Street, across from the original Table Supply. Above the market was the original New York Hotel, later the Albany Hotel, and at this point, Sequoia Rooms. (Martzen Studio.)

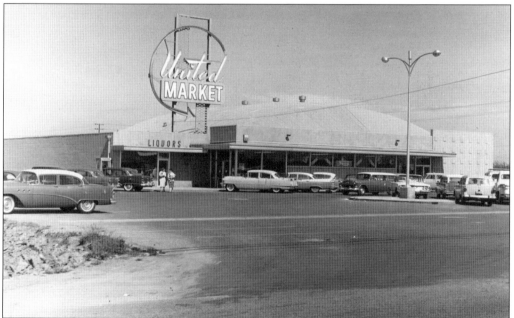

In 1960, Dinuba got its first supermarket, as the United Market moved from the small store on Tulare Street to a huge new store on Crawford Avenue at El Monte Way. The store is still in the same location. (Martzen Studio.)

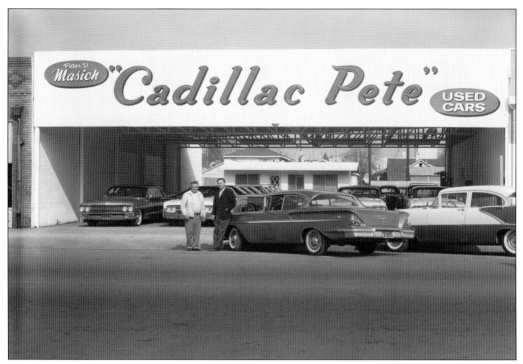

"Cadillac Pete" Masich was perhaps the best-known car salesman in Tulare County. Ever flamboyant, he opened this used car dealership specializing in luxury cars. Pete is leaning against a Chevrolet Bel Air about 1961. (Martzen Studio.)

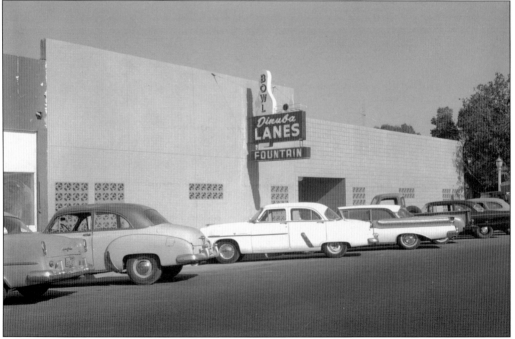

In the late 1950s, the Pep Theater was torn down and something new—a bowling alley—came to Dinuba. Prior to this, bowling fans had to drive to Visalia or Fresno to bowl. (Martzen Studio.)

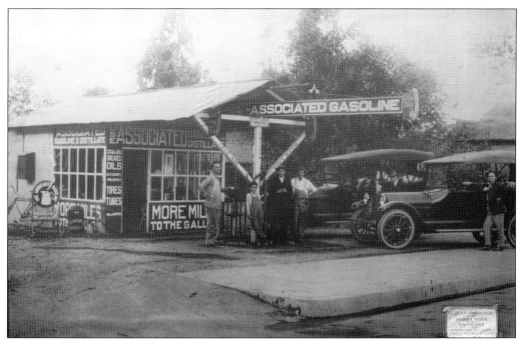

With the arrival of the automobile in Tulare County, and with Dinuba being a boom town at the time, there was an immediate need for a gas station. On April 11, 1917, John Harness purchased two city lots at Tulare Street and El Monte Way and built the Associated Gas station, one of the first gas stations in California. (Alta Historical Society.)

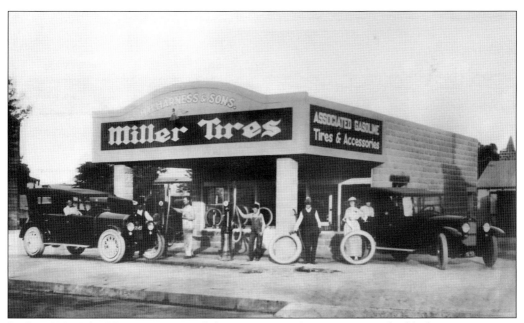

In the 1920s, John Harness petitioned the city trustees for permission to build a bigger gas station on his remaining lot. He is pictured here in front of the gas pumps. (Alta Historical Society.)

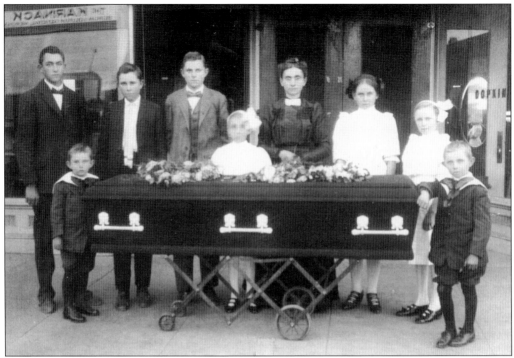

This is the first modern funeral in Dinuba. Prior to modern embalming, bodies were placed in shrouds before being buried. On October 10, 1912, John DeFehr was killed in a train accident outside of Dinuba. Most caskets and coffins were sold by furniture stores. G.M. Dopkins, the local furniture store owner, had gone to San Francisco and been trained to embalm bodies using modern methods. Eventually, Dopkins sold the furniture business and relocated his business to Kern and J Streets, where the Dopkins Funeral Chapel exists today. (Alta Historical Society.)

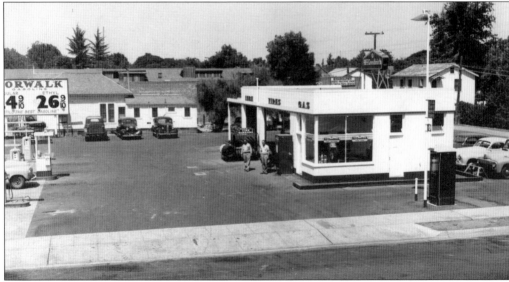

In 1948, the Buick dealership that was located on North L and Fresno Streets burned down. In 1951, Oran Dial Sr. acquired the property and built the Norwalk Station, one of the first major gas stations with automotive repair in Dinuba. (Author's collection.)

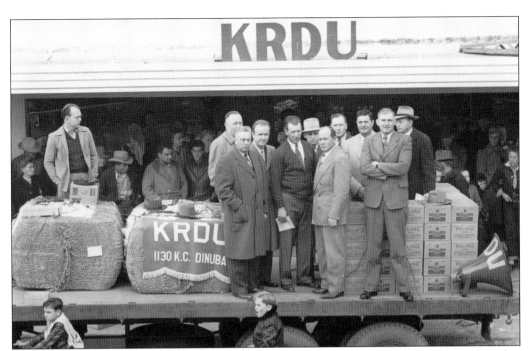

In 1947, something else became a first in Dinuba and the United States, KRDU AM Radio, the first Christian radio station, broadcasting at 250 watts in the daytime only. The broadcast location was on North L Street above Enns Jewelers, adjacent to the Bank of America. To kick off the broadcasting, the radio station used street meetings and giveaways, usually from the back of a flatbed truck. (Martzen Studio.)

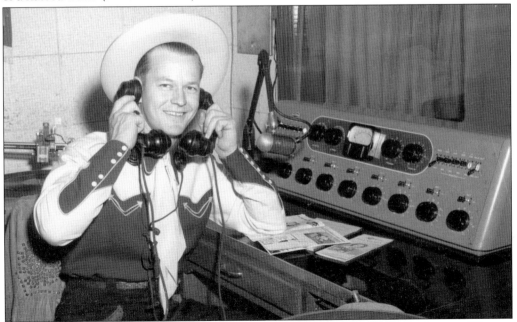

Johnny Banks became a major local personality with a morning show playing Country-Western music and call-ins. He was also a minister at the Dinuba Church of Christ on College Avenue at Magnolia Way. (Martzen Studio.)

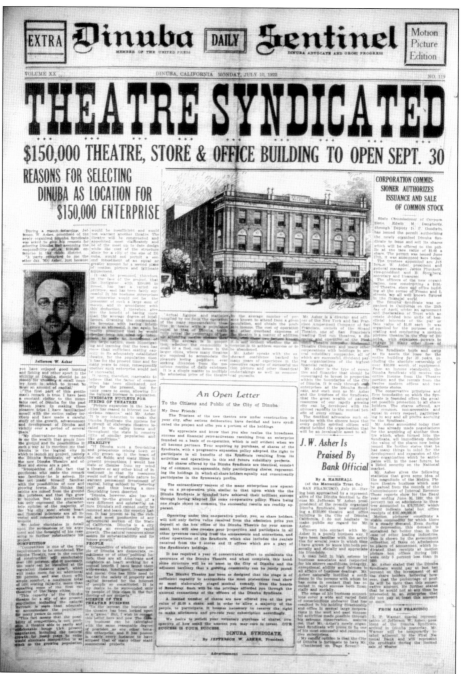

On July 10, 1922, Jefferson Asher, president of Strand Theaters in San Francisco, picked Dinuba as the location to invest $150,000 and build one of the largest and most elaborate motion picture theaters in California, seating almost 2,500 people. The theater was to be built on the corner of North L and Fresno Streets. The Strand Theater was huge news, and the construction of the theater was to be syndicated, meaning public shares of stock would be sold. This was before all of the changes to securities laws that would come in 1933 and 1934 during the Great Depression, and little is known as to what really happened other than that the theater was built. (*Dinuba Sentinel*.)

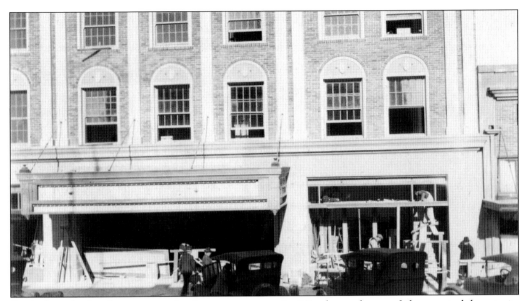

Even though the theater was the largest structure in Dinuba and one of the most elaborate in California, this is the only known photograph of its construction, and this was only taken near the end. (Olson family.)

This is the opening-night program for the Strand on February 3, 1924, showing Jefferson Asher as the general manager. The theater interior was very elaborate, with gold leaf on much of it and a stage that at one time held an elephant during a vaudeville show. (Vetter family.)

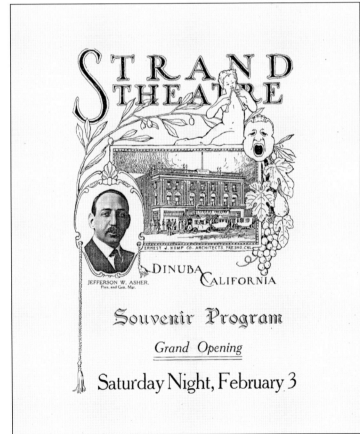

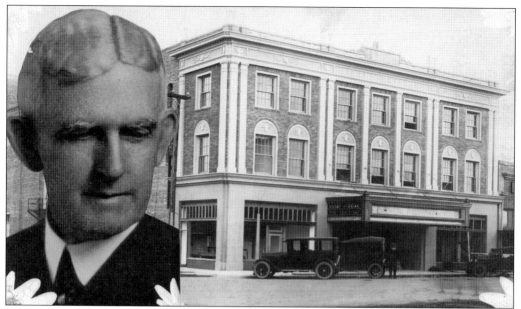

It is unclear what happened financially to the interest of the Strand Company, but shortly after the opening, Clarence Wilson apparently assumed ownership of the theater, and nothing more is heard about the Strand Company, although the name "Strand Theater" is still engraved at the top of the building. The final architect for the building was Earnest Kump, who went on to design much of the University of California. (Olson family.)

Ushers and usherettes were sought-after jobs, as it was prestigious to work at the new theater. Some of the ushers had second jobs, going down to the rail yard after the theater closed and filling railcars with ice for fruit shipments. (Vetter family.)

After the change in ownership, the theater changed its name to the State Theater, and Shorty Kelly was hired to manage it. For the first time, Dinuba became a destination for major motion pictures and vaudeville acts. (Martzen Studio.)

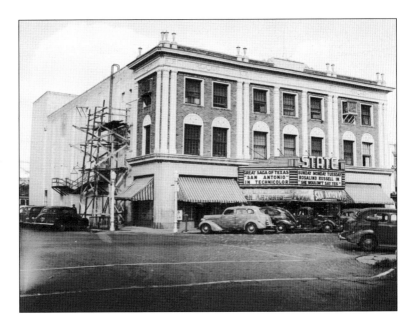

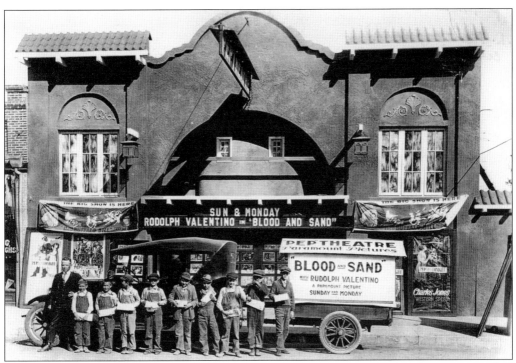

The other theater in Dinuba was the Pep Theater. Much smaller and older, the Pep opened in 1922 with a Rudolph Valentino movie. In the early days of motion pictures, studios sponsored theaters as a means of distributing their films. The Pep was affiliated with Paramount Studios. (Alta Historical Society.)

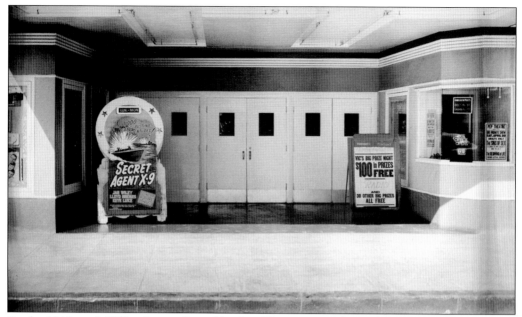

By the 1940s and 1950s, the smaller, older Pep Theater was relegated to showing serials and B movies. This was an attempt to draw the younger crowd, which was captivated by movie serials. Without air-conditioning, the older theater crowd flocked to the more modern State Theater. (Martzen Studio.)

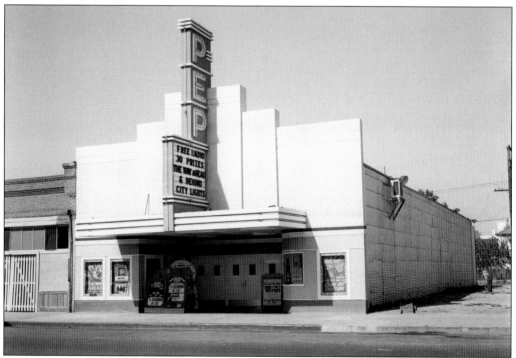

By the 1940s, even though the exterior was remodeled, the Pep Theater still had trouble competing with the State Theater up the street. By 1960, it had closed and was torn down to make way for the new bowling alley. (Martzen Studio.)

Four

INFRASTRUCTURE

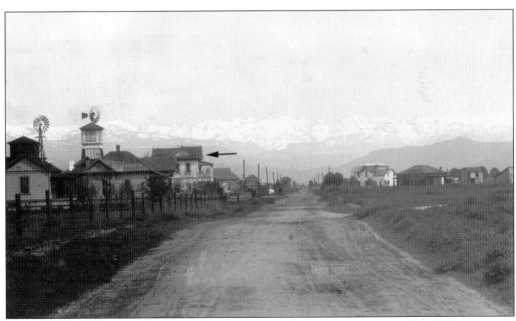

El Monte Avenue is seen looking east to the Sierra Nevada. The arrow points to Dr. W. Whittington's home. He was the first medical doctor in Dinuba and an early city official. The home still stands in the same place. (Jeff Belknap.)

Wagons are lined up to load their produce on the train. Almost all of Dinuba's commercial activity involved the Southern Pacific Railroad directly or indirectly. Shipping produce was the economic engine of the city and the entire San Joaquin Valley. Shown here around 1909 are shipments of melons. (Jim Hickman.)

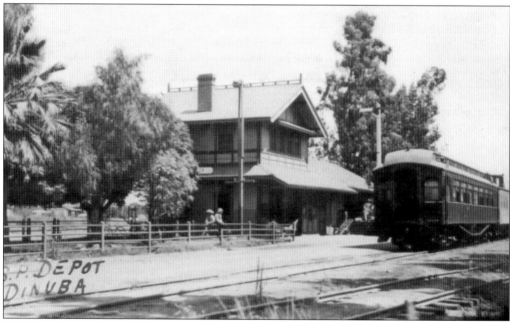

This is the Southern Pacific depot in 1907. The train was the main source of transportation into and out of Dinuba, with Fresno an afternoon ride away. If one didn't take the train, the trip was made by horse and buggy. Fares were a few dollars, with special fares for students of the University of California. The *Sentinel* published the arrivals and departures of people and even published a listing of "suspicious characters." (Dinuba Historical Society.)

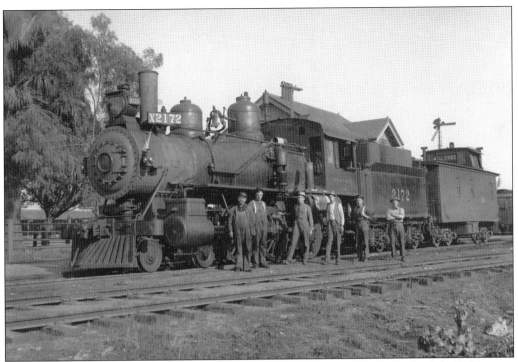

Dinuba's first regular train crew is pictured in 1915. Locomotive No. 2172 was built by Baldwin in 1913 for the Southern Pacific, one of several Class T 57 locomotives, the "T" referring to the 4-6-0 wheel configuration. No. 2172 served Dinuba for several years and was leased by the Southern Pacific to the Clackamas & Eastern Railroad in Oregon in the 1930s. It served in Oregon until it was one of the final two Class T 57 locomotives to be scrapped. (Author's collection.)

On June 10, 1914, Mrs. C.B. Driver of the Dinuba Woman's Club appeared before the city board of trustees asking for a site in City Central Park for a clubhouse. A discussion ensued about the possibilities for the park and ended with a special committee being appointed to investigate a library. In October 1914, the city received funds from philanthropist Andrew Carnegie to construct a new library, which opened in 1916. (Alta Historical Society.)

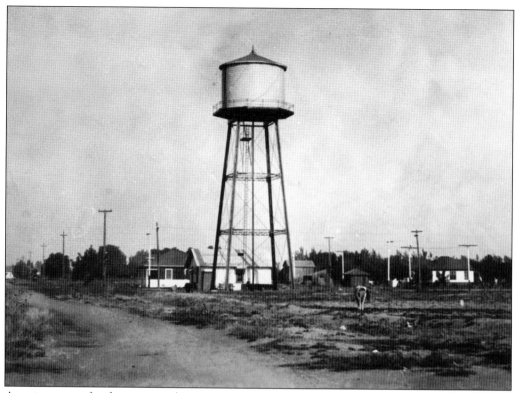

A major reason for the municipal incorporation in 1906 was to develop a municipal water supply to help fight the relentless fires that routinely destroyed homes and commercial buildings. The dry, hot summers and the use of kerosene for lighting were blamed for most fires. One of the first acts of the city trustees was to erect a water tower to provide water pressure. This is the first water tower, built in what would become City Central Park, land that had been donated by the Southern Pacific Railroad. (Alta Historical Society.)

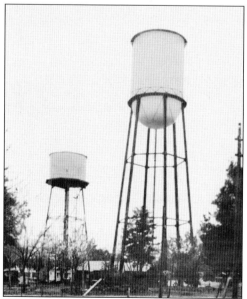

In July 1922, the engineering firm of Martzen and Price found that the floor timbers of the old water tower were rotted and that the tower was in danger of imminent collapse. The city contracted with Des Moines Steel (the same company that built the newest water tower) to build a new water tower, 110 feet tall and holding 200,000 gallons, the second largest water tower in California. This is the only known photograph of the two water towers side by side in City Central Park. (*Alta Advocate*.)

The Dinuba water tower could be seen for miles from every direction before getting to the city, and the tower paired with the Carnegie Library became an iconic image of the town. The library was replaced in 1975 with a new facility. (Alta Historical Society.)

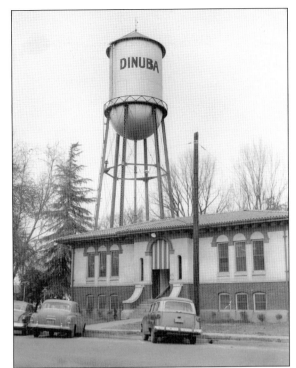

This is a photograph of the telephone exchange when there was no dial service. To make a phone call, an operator answered a phone with "number please" and then connected the call. This system was in service until the late 1950s. (Martzen Studio.)

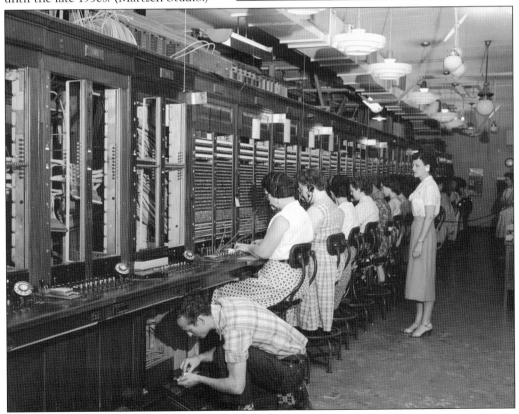

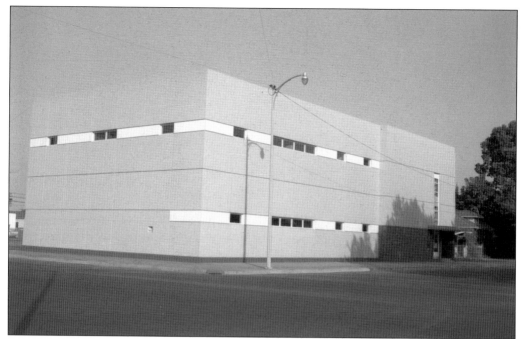

In 1958, the old telephone exchange was replaced with an automated dial-up system and a new building at Fresno and K Streets. The new exchange was a plain, air-conditioned, high-security building. (Martzen Studio.)

This is a sketch of the first school building in Dinuba. Not much is known about its location or duration other than that it was replaced by the Dinuba School in 1890. This school served Dinuba when the population of the village was less than 100. (Alta Historical Society.)

The Dinuba School was built in 1890 and dedicated on April 11. The three-story brick building was called the "Grandest School in California" by the *Alta Advocate*. When this school served the area, the population of Dinuba was less than 120. (Alta Historical Society.)

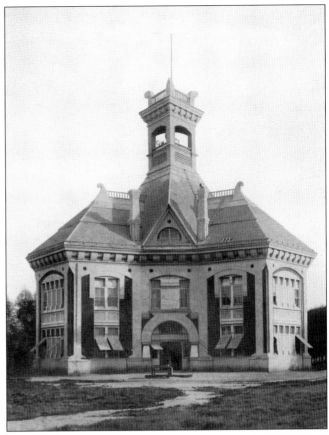

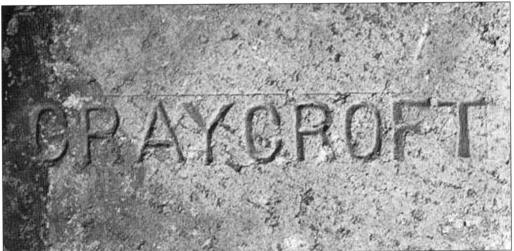

The school and other buildings in Dinuba were built with Craycroft bricks, taken from a "hog wallow" brick pit in the middle of a block on the west side of North L Street. Unfortunately, the bricks used to build the school were either flawed or just not kilned sufficiently, for they were soft. After the San Francisco Earthquake of 1906, the cupola was found to be unstable and would rock from side to side if pushed, so the "Grandest School in California" was torn down. (Alta Historical Society.)

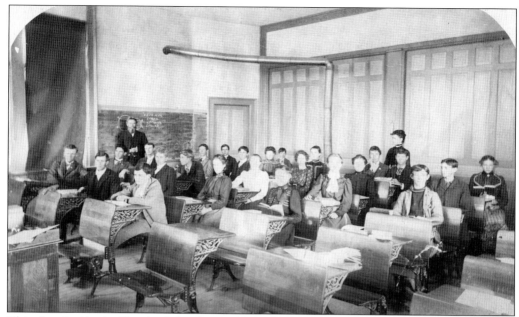

This class inside the Dinuba School is studying geometry around 1895. Notice the wide range of ages among the students. Age ranges for different grades were less standardized at the time. (Alta Historical Society.)

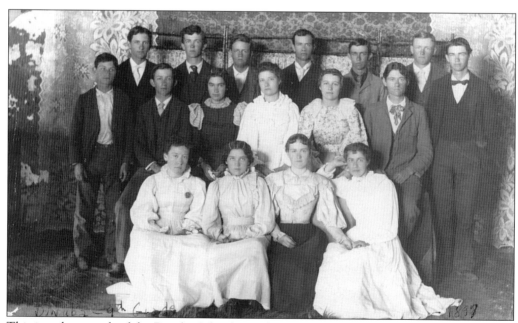

This is a photograph of the Dinuba School's ninth-grade class in 1897. Notice the age disparity. The teacher, in the middle of the back row, is C.E. Horsman, who is also at the bottom of the next page. (Newton family.)

In 1901, students of the Reedley School traveled eight miles to Dinuba to visit this grand structure, a bit of a journey by horse and wagon. Notice the age diversity in the crowd. (Alta Historical Society.)

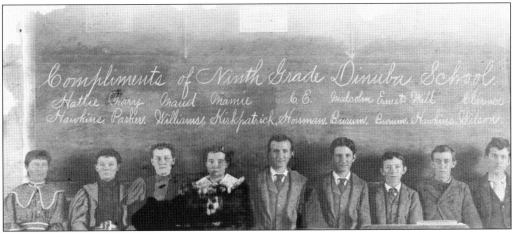

The Dinuba School's 1897 ninth-grade class was, from left to right, Hattie Hawkins, Mary Parker, Maud Williams, Mamie Kirkpatrick, teacher C.E. Horsman, Malcom Burum, Ernest Burum, Will Hawkins, and Clarence Wilson. Many of these students went on to become prominent citizens. (Olson family.)

The Dinuba School's entire student body assembled for the celebration of the Fourth of July in 1901. There are no sidewalks leading up to the entrance of the school, only wooden planks laid in the mud and dirt. (Alta Historical Society.)

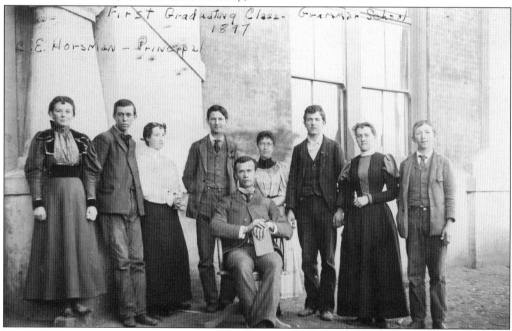

This is the first graduating class from Dinuba School in 1897. C.E. Horsman is the principal and teacher. The girl on the left is standing on a brick to make her as tall as the other students. (Alta Historical Society.)

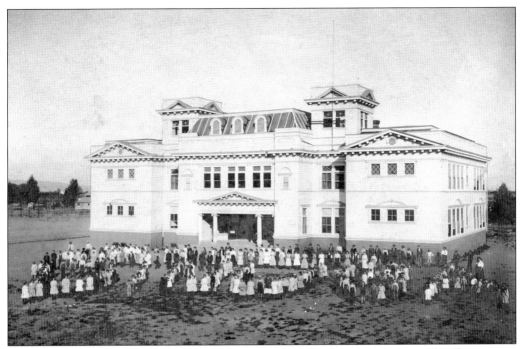

This is a 1909 photograph of the new Dinuba Grammar School, not nearly as grand as the previous school. The students are standing to spell out "Dinuba." This three-story school was built of wood, not brick, and served for many years. It was located where the old Washington Junior High School was on Sierra Way and College Avenue. (Author's collection.)

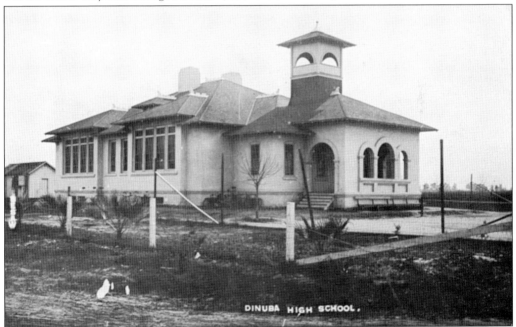

This c. 1909 photograph shows the first Dinuba High School. Prior to the high school, all grades attended one school. This first high school burned and was replaced in 1914. The school burned again in 1936 and, during construction, it burned again in 1937. (Jeff Belknap.)

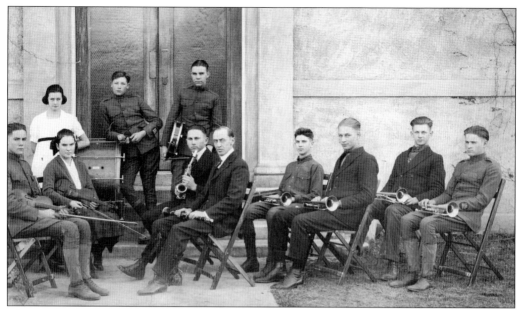

The Dinuba High School Orchestra is pictured around 1910 in front of the new high school. Dinuba was always a supporter of music in its schools, having programs in elementary schools as well as a band in its junior high school. (Alta Historical Society.)

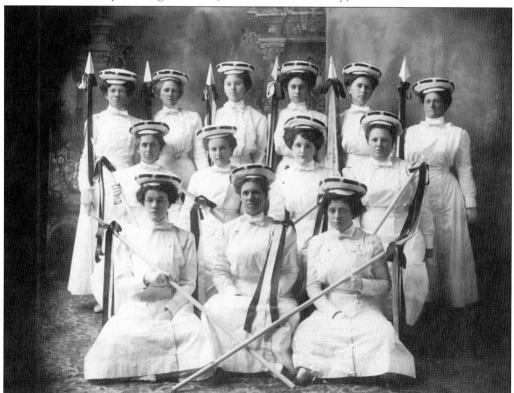

The Dinuba High School women's drill team poses in 1912. The uniforms and spears show Greek influence, a major social interest of the time. (Olson family.)

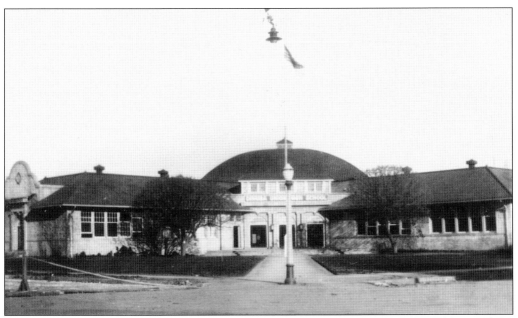

Dinuba's second high school is pictured in 1914. Notice the angled wings of the building and the new streetlight in front, under the old hanging streetlight. (Jeff Belknap.)

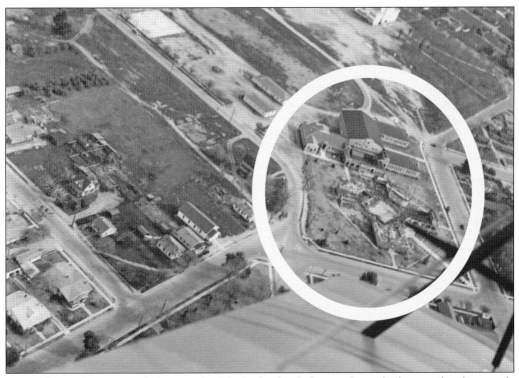

This is the first known aerial photograph of the high school, this one from a biplane, and unfortunately shows the school as it was burned to the ground around 1936. (Alta Historical Society.)

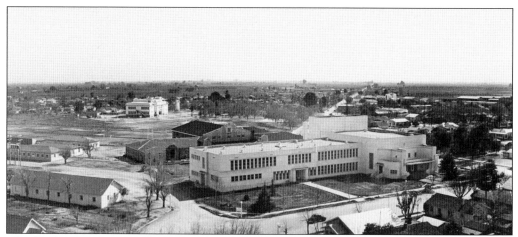

The third and final Dinuba High School is pictured around 1937 as it looks today. The photograph was taken from atop the Dinuba water tower. In the background is the Dinuba Grammar School. (Martzen Studio.)

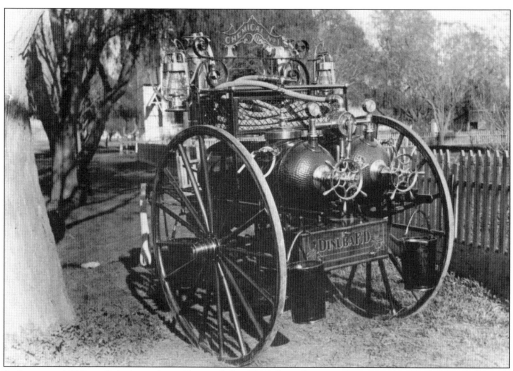

In January 1907, still feeling the effects of the 1901 fire, the new city trustees authorized the fire committee to acquire the first major piece of firefighting equipment, this chemical unit. (Robert Gapen family.)

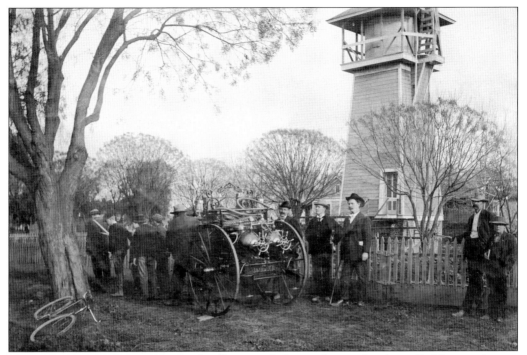

In April 1909, the fire equipment finally arrived. It was designed to be pulled by people, not horses. The unit was parked near the water tower for the First Baptist Church, near the current post office. Even though fires continued to occur, it is not clear that this unit was ever used. It remained parked and fell into disrepair. (Robert Gapen family.)

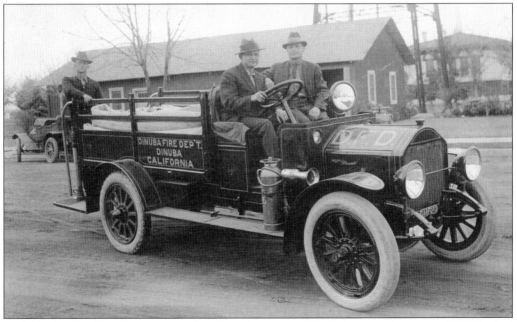

In 1916, the City Fire Committee ordered another piece of firefighting equipment, a 1916 Garford fire truck, to carry hoses, buckets, and handheld fire extinguishers. This was the first piece of motorized equipment. (Arlo Westmoreland.)

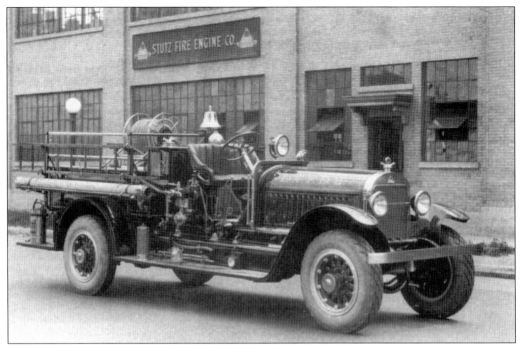

The first piece of modern fire apparatus was purchased in 1922 from the Stutz Fire Engine Company, a Stutz Model C Pumper. It featured a 750-gallon-per-minute pump with a booster tank instead of a chemical unit. This picture was taken at the factory in 1922. (Arlo Westmoreland.)

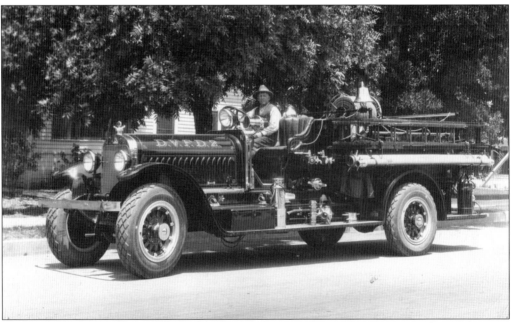

The Stutz is pictured with all of the hoses, ladders, and other equipment shined to perfection. Notice "D.V.F.D. 2" in gold leaf on the hood. The only downside of this truck was its lack of power steering. Turning corners with a load of water on board took real muscle. (Jeff Belknap.)

In the Board of Trustees of the City
of Dinuba, Cal June 13th 1906.
Present Trustees Dunn, Dopkins
and Hauser, Absent. Trustees Willson
and Ranum,
Meeting called to order by the
President R. F. Dunn,
Minutes of last meeting read
and approved,
The clerk was instructed to
write to the manager of the Sun
Set Telephone Co, and request him
to place the inside of the poles, not
more than two feet from the curbing
so as to conform with the Electric
light poles.
The Fire department committee
was instructed to procure 500 feet
of 2 inch hose and noyles, also to
secure a place to house the hose
and ladders + buckets,
Ordenances No. 21 and 22 was
proposed for adoption at the next
meeting,
The following bills was duly
allowed, and warrants ordered
drawn on the Treasurer for same
E. C. Reese, Salary 876 00/100
Fresno Nursey Co, Trees " 123 75/100
H. Hurst Printing " 3 75/100
Adjourned until next
regular meeting, June 20th 1906
 J. F. Boone
 Clerk

On June 1, 1906, following the election of the first board of trustees (now the city council), the first action was to appoint a fire committee and designate a fire department, the first city department. Here, the minutes of the June 13 meeting authorize the purchase of the first fire equipment for the city. (Author's collection.)

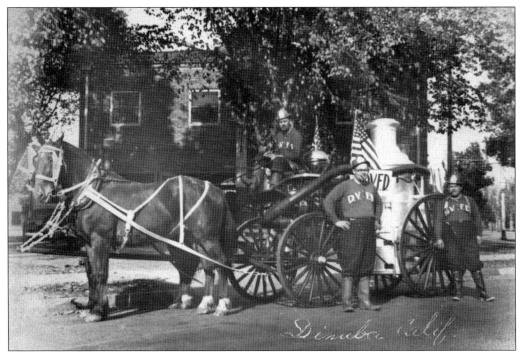

An example of misleading common belief is this photograph of a horse-drawn Silsby Steam Pumper. Many people thought Dinuba had a horse-drawn steam pumper, but it is clear from the council minutes that Dinuba never owned nor possessed a horse drawn pumper, nor even a place to park one. This unit was probably borrowed from Visalia for a parade. (Alta Historical Society.)

The Dinuba Fire Department in 1927 finally had enough equipment to fight a small- to medium-sized fire. This was the new fire station, built in City Central Park. The station had bedrooms upstairs and a real brass fire pole. (Alta Historical Society.)

With all of the equipment the city had acquired, the fire department was still short of necessary equipment for a large fire. The city negotiated for Tulare County to station this fire truck and one man at the Dinuba Fire Department in 1940. This enabled Dinuba to respond to fires that were just outside the city limits and have this truck for backup in the event of a major fire. (Arlo Westmoreland.)

Large, disastrous fires continued to plague and redefine the Dinuba landscape. In 1948, fire broke out in the Buick dealership at Fresno and North L Streets, burning the building to the ground. This became the site for the Dial Service Norwalk gas station in 1951. (Martzen Studio.)

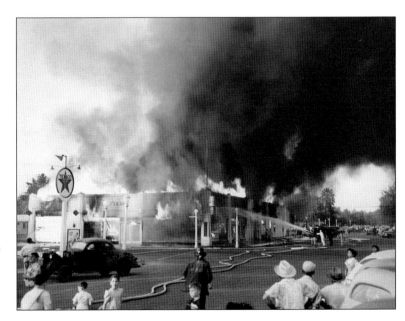

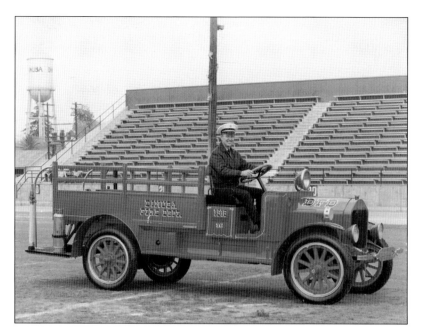

Bob Gapen is sitting in the restored 1916 Garford fire truck parked on the Dinuba High School football field. Gapen was a very popular postal carrier in Dinuba and led a group of dedicated men to restore the truck for use in parades and other occasions. (Robert Gapen family.)

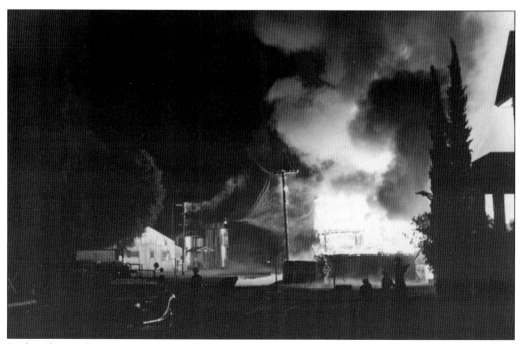

Packinghouse fires were the bane of agricultural business in Dinuba for 80 years. Dry wood and electrical shorts were common, and the lack of a full-time paid fire department meant a slow response time, so the structure usually burned to the ground. (Jeff Belknap.)

Five

CHURCHES AND PEOPLE

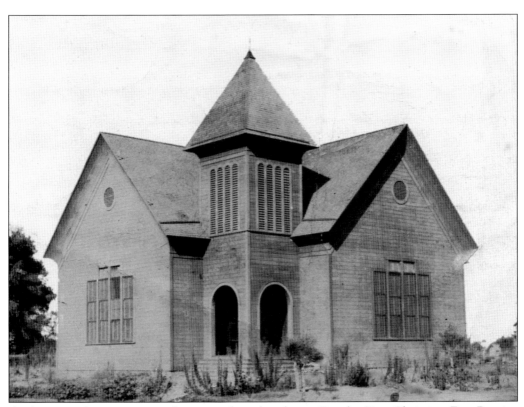

At the time of incorporation, there were four churches in Dinuba: First Christian, First Baptist, Presbyterian, and Methodist. None of the original buildings still exist except for the First Christian Church, which was moved from Munson in 1905. (Alta Historical Society.)

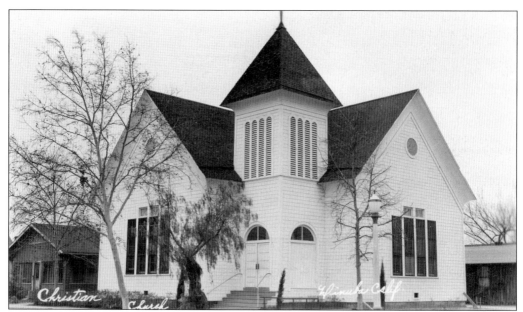

This is the First Christian Church in the 1960s. It looks very similar today except for a small addition to the front. It is now used by a different denomination. (Jeff Belknap.)

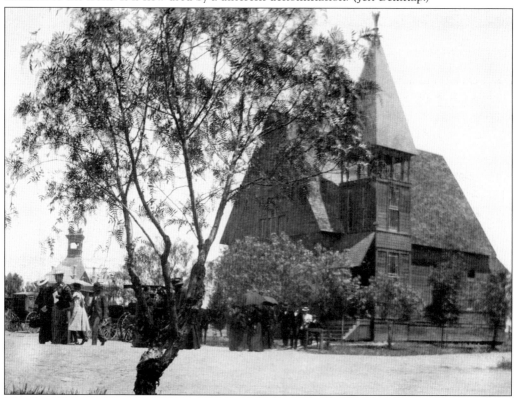

The First Baptist Church, built in 1892 on the corner of Kern and K Streets, was originally unpainted. The congregation moved in 1923 to a new building that burned to the ground on December 31, 1929. The Dinuba School can be seen in the background. (First Baptist Church.)

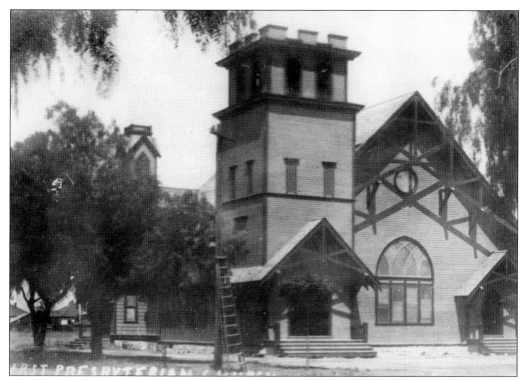

The First Presbyterian Church was organized in 1894 and for a while met with the other three churches at the Wilson School, each taking a Sunday and rotating the fifth Sunday. In 1900, the Traver church was moved from Traver to Fresno and J Streets. The church burned just as a new building was being finished in 1923. (Alta Historical Society.)

In 1922, Samuel Cochran led an effort to build a new church. The Presbyterian church at the corner of Merced and K Streets is pictured shortly after the $100,000 construction was finished in 1924 and as it appears today. (Alta Historical Society.)

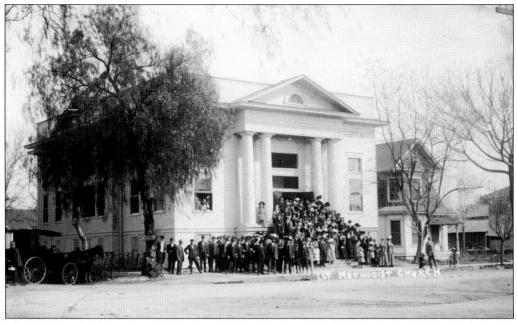

The First Methodist Church is pictured around 1920. Churches in Dinuba cooperated a great deal with each other. The second Baptist church building was purchased from the Methodist church in 1931, making it somewhat difficult to tell which congregation was worshiping in what building in the early years. (Newton family.)

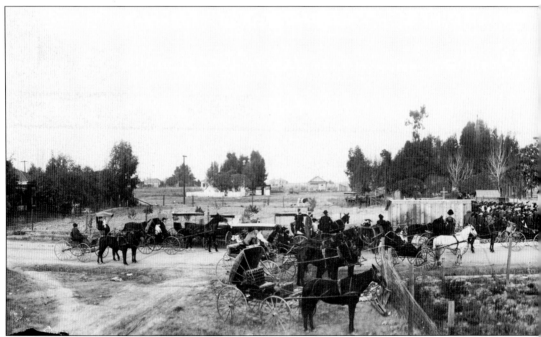

Due to the hot summers and fall, churches would dismiss services in their buildings and on Sunday come together outside for evening services. This photograph shows such a meeting at the First

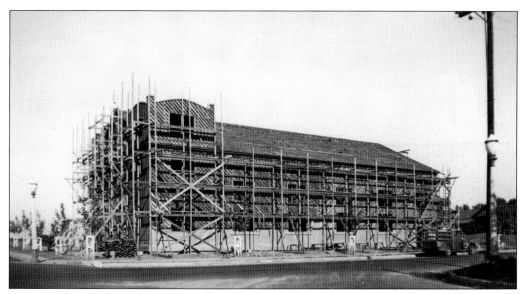

In 1909, Johann Kleinsasser became dissatisfied with the Mennonite Brethren in South Dakota, and he and his sons purchased 3,200 acres near Dinuba. In 1910, he moved his own and eight other Krimmer Mennonite Brethren families to Dinuba. Eventually Dinuba and Reedley would become the most favored Mennonite relocation destinations in the United States. (Jake Enns.)

Baptist Church around 1900. (Author's collection.)

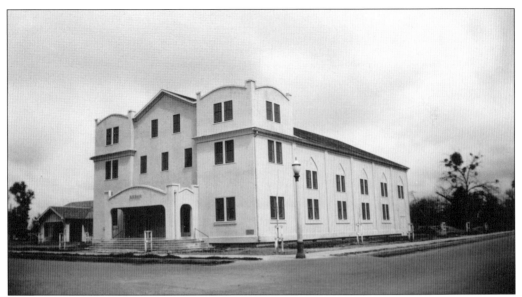

In 1937, the German Mennonite Brethren broke ground on a new building on El Monte Way. When it was finished in 1938, the Dinuba Mennonite Brethren Church became one of the largest churches in the city. (Jake Enns.)

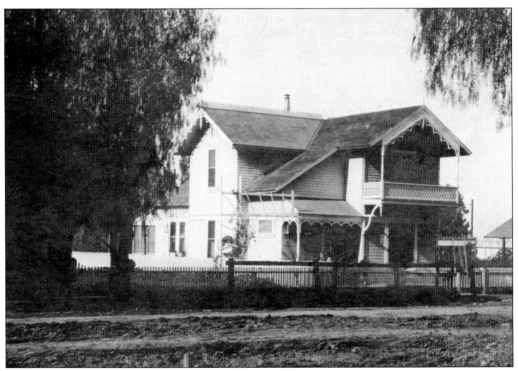

This is a c. 1909 photograph of the home of Dr. W. Whittington on El Monte Way. Dr. Whittington was the first medical doctor in Dinuba and was appointed to head up an effort after incorporation to clean up sewage and mosquitoes, which were problems in the city. The home is located in the same place across from the current city hall, painted pink with white trim. (Jeff Belknap.)

Bart Patterson, the son of James Patterson, is pictured in 1907. Although they lost almost everything prior to moving to Dinuba, the Patterson family prospered here, and Bart was a prominent citizen. (Newton family.)

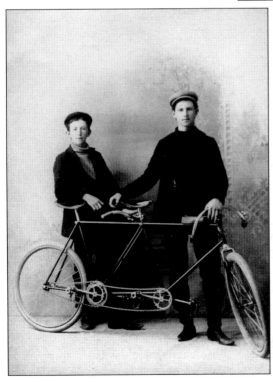

Ernest (left) and Malcolm Burum (right) were sons of Ernest and Mary Burum, who operated Burum's Department Store in the Karnak Building. (Alta Historical Society.)

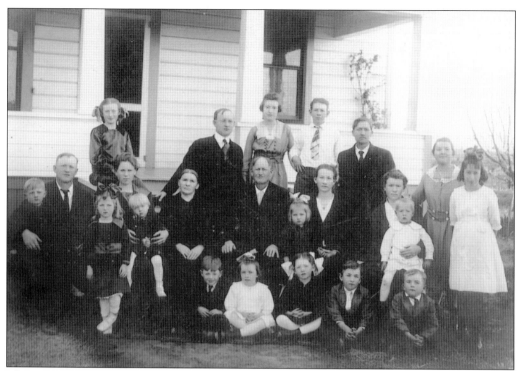

The Martzen and Vogle families are seen here around 1920. One of the children is David Martzen, who founded the Martzen Studio, taking all of the school photographs and many municipal photos from the 1940s through the 1960s. (Barbara Martzen.)

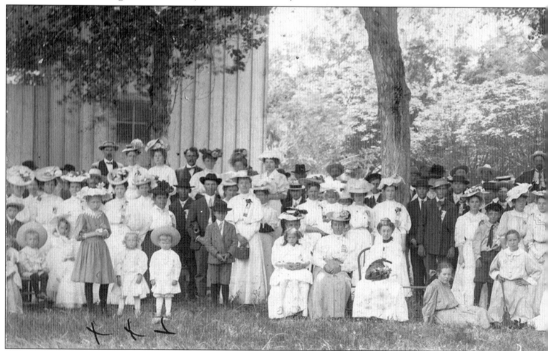

Pictured are the Patterson and Wallace families. James Patterson sought a place to raise his family

Judge M.T. Wallace (left) is pictured here in his office on South L Street. Notice that the office has a few law books but is not as elaborate as legal offices today. Wallace served as the local judge from 1904 to 1926. He was related to the Patterson family. (Barbara Richardson.)

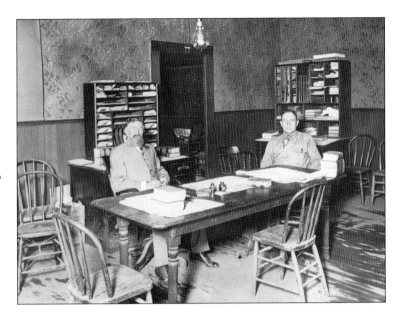

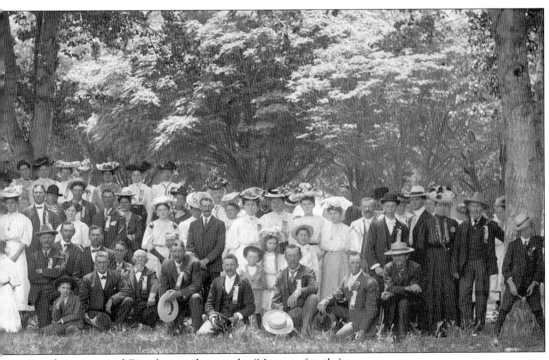

and prosper, and Dinuba met his needs. (Newton family.)

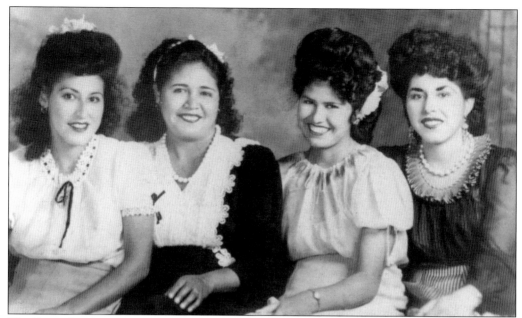

The Rivas family was one of six families that fled to Dinuba during the Mexican Revolution, which continued until 1920. The Rivas sisters shown here about 1945 are, from left to right, Adella, Soccoro, Nicolasa, and Eleanor. The sisters went on to become the matriarchs for much of the Hispanic community in Dinuba. (Connie Prado.)

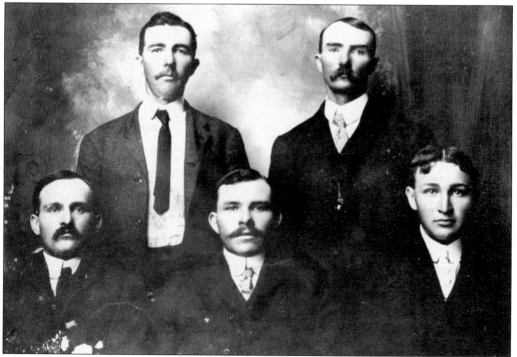

The Vetter and Randolph brothers are pictured here. The Vetter family went on to own a cabinet and construction company. The Randolphs owned the Wells Fargo Stage Depot, which evolved into an automobile repair garage. (Vetter family.)

Six

STREETS

Even though the land was fairly flat, the streets still needed to be graded for drainage during storms. Mules are being used to grade K Street around 1895. The town grew primarily eastward from the city center. (Newton family.)

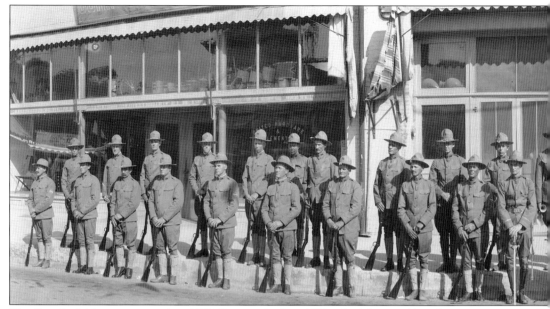

The Dinuba Militia is pictured in 1918. During the late 1910s, the Mexican Revolution was very active along the California border with Mexico. In June 1916, Francisco "Pancho" Villa led a raid on Columbus, New Mexico, and Gen. John "Blackjack" Pershing began calling up National

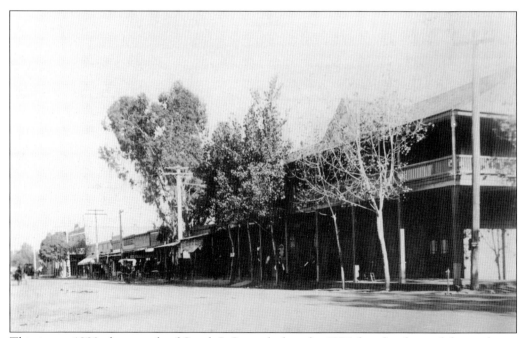

This is a c. 1900 photograph of South L Street before the 1906 fire that burned down almost the entire block. At the end of the block, the Commercial Hotel can be seen. Adjacent to the Dinuba Hotel is Mrs. Carlson's Delicatessen. (Alta Historical Society.)

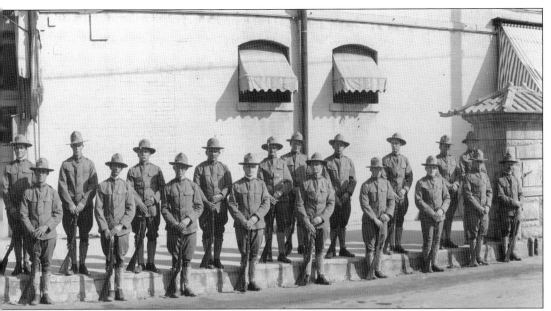

Guard units to reinforce the border. Cities in central California formed militias almost overnight to reinforce the National Guard. (American Legion Post 19.)

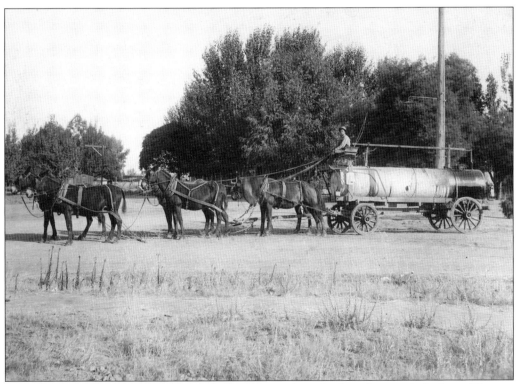

Before the downtown streets were paved, the summers brought dust along with the heat. The city hired a driver to wet down the dry streets. Shown around 1907 is Wes Shane driving the second water wagon. Kids used to chase the wagon to feel the cool water. (Martzen estate.)

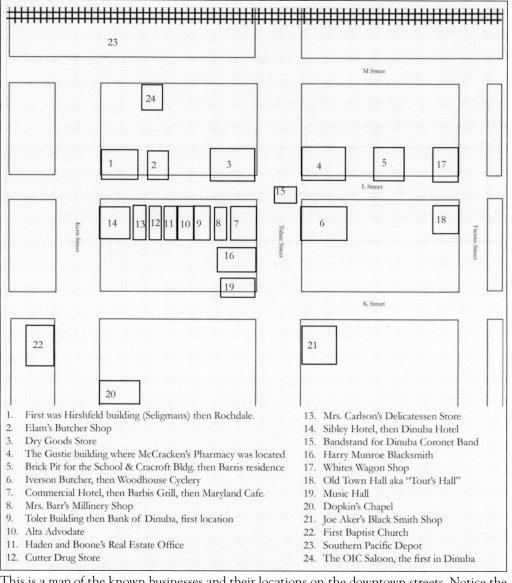

1.	First was Hirshfeld building (Seligmans) then Rochdale.	13.	Mrs. Carlson's Delicatessen Store
2.	Elam's Butcher Shop	14.	Sibley Hotel, then Dinuba Hotel
3.	Dry Goods Store	15.	Bandstand for Dinuba Coronet Band
4.	The Gustie building where McCracken's Pharmacy was located	16.	Harry Munroe Blacksmith
5.	Brick Pit for the School & Cracroft Bldg. then Barris residence	17.	Whites Wagon Shop
6.	Iverson Butcher, then Woodhouse Cyclery	18.	Old Town Hall aka "Tout's Hall"
7.	Commercial Hotel, then Barbis Grill, then Maryland Cafe.	19.	Music Hall
8.	Mrs. Barr's Millinery Shop	20.	Dopkin's Chapel
9.	Toler Building then Bank of Dinuba, first location	21.	Joe Aker's Black Smith Shop
10.	Alta Advodate	22.	First Baptist Church
11.	Haden and Boone's Real Estate Office	23.	Southern Pacific Depot
12.	Cutter Drug Store	24.	The OIC Saloon, the first in Dinuba

This is a map of the known businesses and their locations on the downtown streets. Notice the clustering of businesses on South L Street. Before the fire, this was the center of business activity, but even though the neighborhood was rebuilt, the center of commerce shifted to North L Street. (Author's collection.)

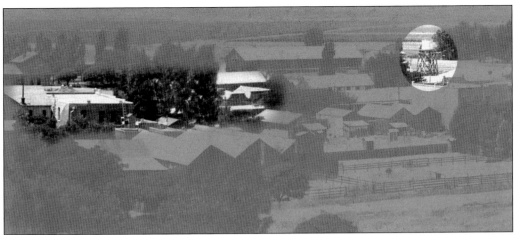

This 1903 photograph shows the parts of South L Street that were burned to the ground, and the location of D. Dickey's water tower. Dickey had laid pipe and provided water under pressure for the downtown area, but only to Tulare Street. When the fire broke out in the middle of a block of South Tulare Street, the only way to stop it was with water-soaked blankets. The fire burned the entire block, then the center of town. (Author's collection.)

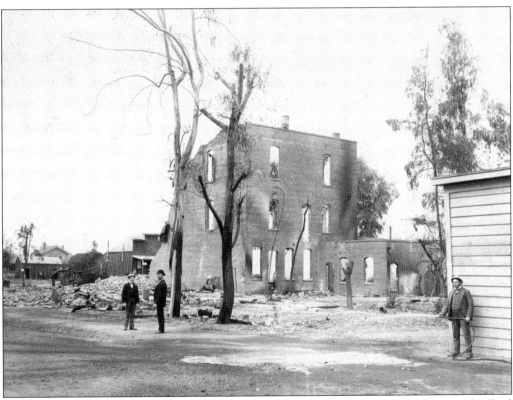

What was left of the Dinuba Hotel is seen from the back the morning after the fire in 1901. Emil Seligman, a survivor of the Traver fire, went to Visalia and underwrote loans for businessmen to rebuild, saving the town. The hotel was rebuilt, and the pattern of the fire can still be seen on the bricks of the outside walls. (Alta Historical Society.)

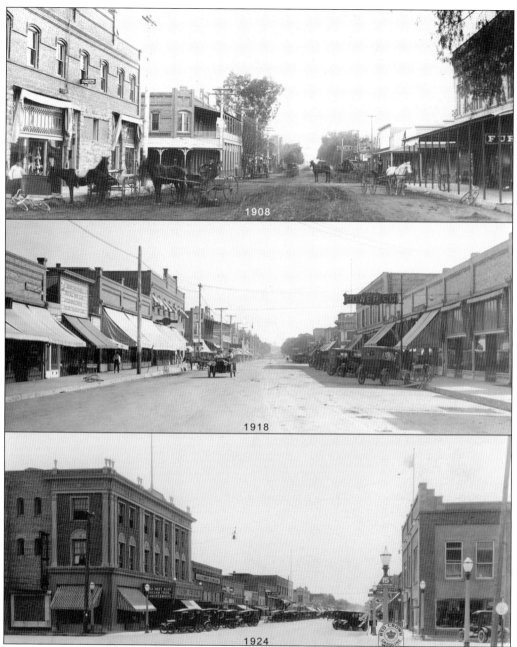

This three-photograph series shows downtown Dinuba from North L Street in 1908, 1918, and 1924. The 1908 photograph shows the power company in the 100 block of South L Street and the general goods store where the First National Bank of Dinuba would soon be built. The 1918 photograph shows the Bank of Dinuba on the right, and the power company has moved to North L Street. On the left side, in the 100 block of South L Street, can be seen the side of Woodhouse Cyclery, where motorcycles were sold. In the 200 block of South L Street can be seen the Dinuba Garage. The 1924 photograph shows the first speed limit sign of 15 miles per hour and the prominent State Theater. (1908 and 1918 photographs, author's collection; 1924 photograph, Alta Historical Society.)

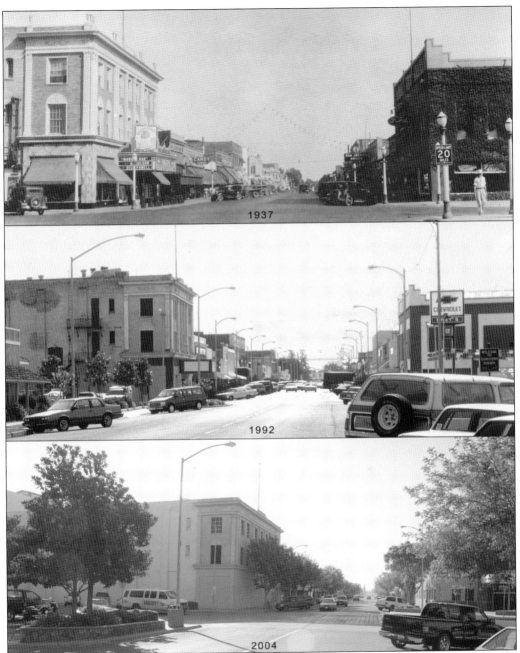

These three photographs show downtown Dinuba from North L Street in 1937, 1992, and 2004. The 1937 photograph shows downtown as a thriving business district. The power company is now called San Joaquin Power, and the speed limit has been increased to 20 miles per hour. The 1992 photograph shows the downtown starting to struggle. The State Theater has closed. The power company became Pacific Gas & Electric and relocated. The 2004 photograph shows the downtown with less traffic. Trees have been planted, and the Tulare County Vocational Center can be seen on the right. (1937 photograph, Alta Historical Society; 1992 photograph, Newton family; 2004 photograph, author's collection.)

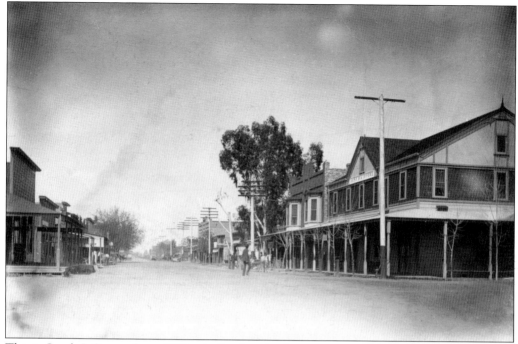

This is South L Street about 1905, rebuilt after the fire using more brick. The Roachdale store is on the left, and telephone lines have been strung, but the streetlights have yet to be erected. (Alta Historical Society.)

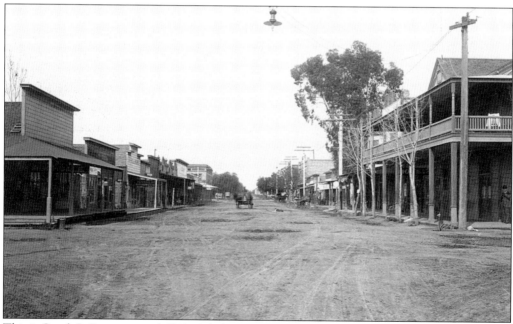

This is South L Street around 1910. A balcony has been added to the Dinuba Hotel. The Gusti Building can be seen down the street on the left, and the Roachdale store has added its sign in the front. South L Street is still the center of town. (Alta Historical Society.)

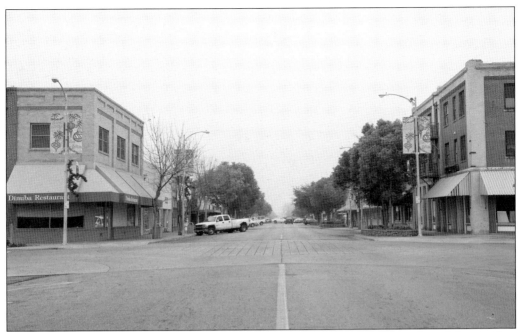

This is South L Street in 2004. The Dinuba Hotel had the balcony removed, and the city has planted trees. Otherwise, the view has changed little in 100 years. (Author's collection.)

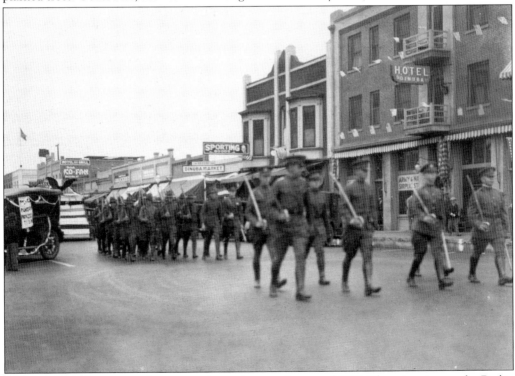

The Dinuba Militia is marching in an Armistice parade around 1922. There is a sign on the Barbis Hotel for Ko-Fan, a popular drink of the time comprised of a couple of pain relievers and caffeine, believed to make one feel better and reduce body temperature. (Alta Historical Society.)

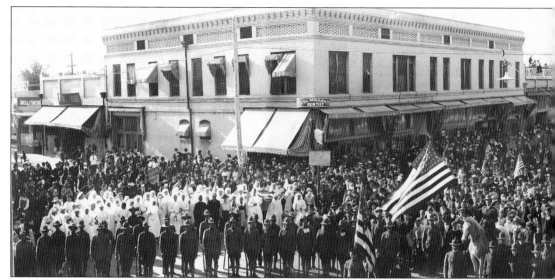

The town gathered at Tulare and L Streets at 11:11 a.m. on November 11, 1918, to mark the armistice ending World War I. The Karnak Building is on the right, and the Gusti Building is on the left. Atop a horse with an American flag is G.W. Wyllie, a former California assemblyman

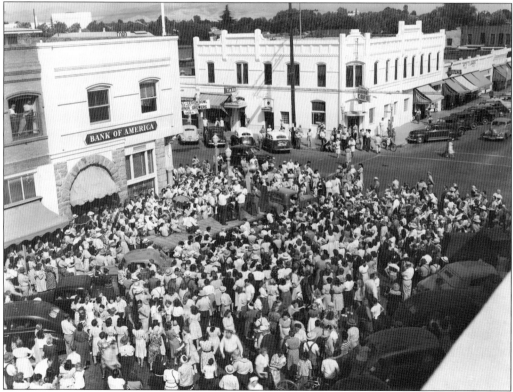

This is a c. 1948 photograph of a downtown raffle. It was customary for a few years for the downtown merchants to sell raffle tickets and then on Saturday afternoon have a drawing for prizes. Eventually the raffle became another reason for local farmers to come to town on Saturday. (Martzen Studio.)

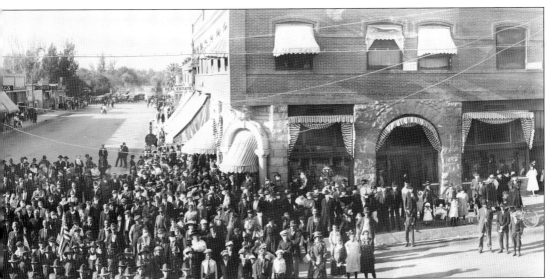

and local politician. The Dinuba Militia can be seen on the left. Many people in the crowd can be seen wearing surgical masks, as the Spanish influenza pandemic was ongoing. (American Legion Post 19.)

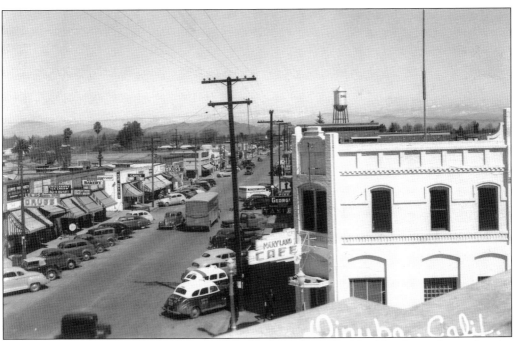

Tulare Street east of L Street is pictured around 1940. The Arbis Hotel has been changed to the Maryland Café and the businesses on the north side of Tulare Street include the Dutch Bakery, a favored landmark that had three more locations in town. In the distance is the Dinuba water tower. (American Legion Post 19.)

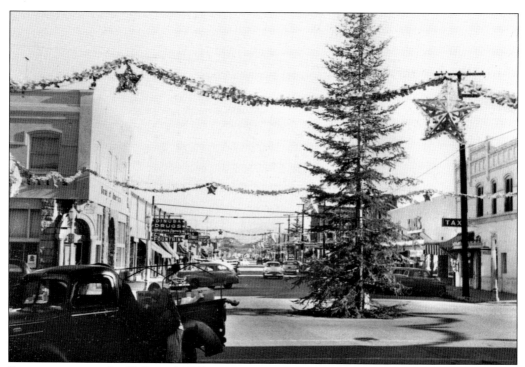

For many years in the 1940s and 1950s, it was customary for the City of Dinuba to obtain a large pine tree from the nearby Sierras, anchor it in the manhole at the middle of Tulare and L Streets, and decorate it as a Christmas tree. This one is from around 1950. (Newton family.)

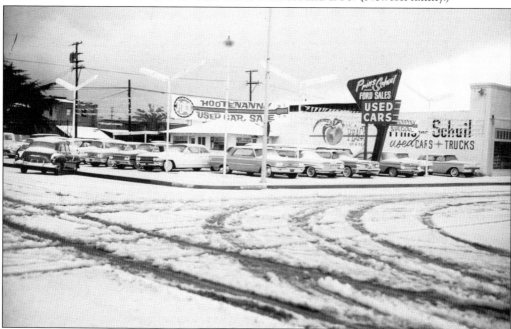

One morning in 1959, Dinuba woke up to three inches of snow. The snow created both fun and a mess, since Dinuba did not have the equipment to deal with it. Pictured is the Prins and Schuil used car lot on Kern and K Streets. (Martzen Studio.)

Seven

LEISURE AND SPORTS

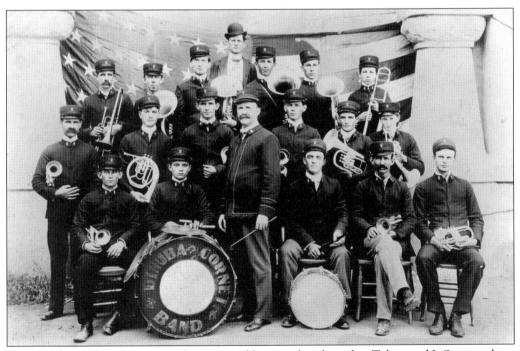

For a brief period, each summer the city would erect a bandstand at Tulare and L Streets where the Dinuba Cornet Band would perform during evenings. The director was Elmer Sibley, and the general manager was Harry Hurst, in the middle of the back row. (Alta Historical Society.)

This is the Dinuba High School class of 1916 Senior Picnic. The Senior Picnic has been a custom for over 100 years. (Leibau family.)

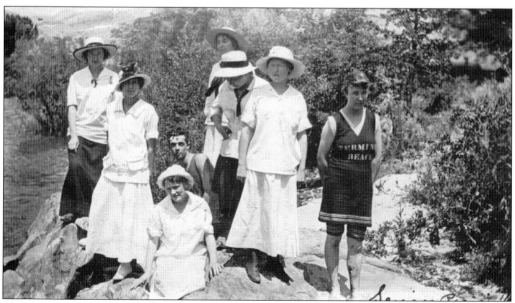

The Kings River was a popular place to go to escape the heat, and it still is. This c. 1916 group of seniors from Dinuba High School enjoys the cool water. (Leibau family.)

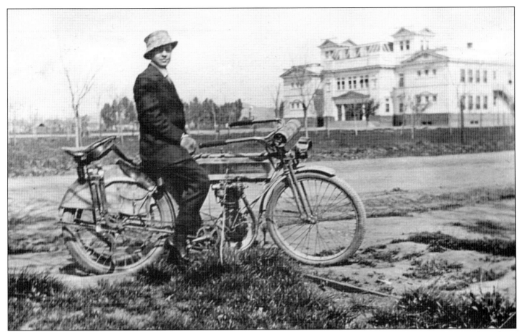

Weaver Leibau is seated on his Excelsior motorcycle in front of the Dinuba Grammar School in a c. 1916 photograph taken by Haddie Patterson. (Leibau family.)

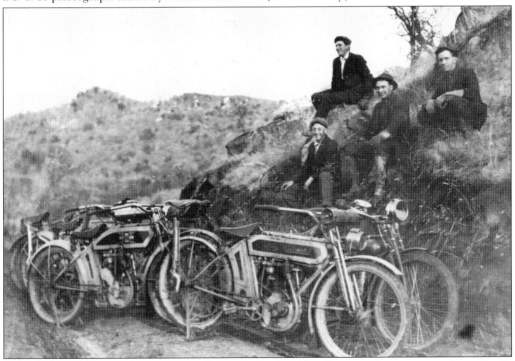

Weaver Leibau and his friends are out for a spin on their Excelsior and Pope motorcycles at Smith Mountain around 1916. The bikes were probably purchased from the Woodhouse Cyclery. The Excelsior motorcycle was in production until 1931, and Pope motorcycles were in production until 1918. (Alta Historical Society.)

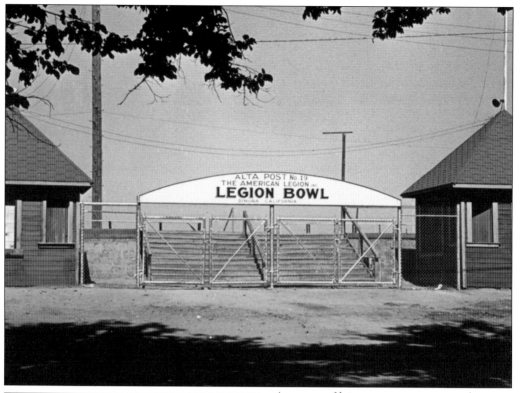

A source of leisure amusement was the Alta Post 19 of the American Legion and its Legion Bowl, located on Alta Avenue. This was a location for rodeos and other pastimes. It is pictured around 1958. (Martzen Studio.)

No rodeo would be complete without the rodeo clowns. Well-known actor and clown Slim Pickens was a frequent player at the Dinuba rodeos in the 1950s. (Martzen Studio.)

A most popular place during the hot summer afternoons was the swimming pool at Dinuba High School, pictured here around 1955. Home to swim teams as well as aquatic fun, the pool could be accessed for just a dime. (Martzen Studio.)

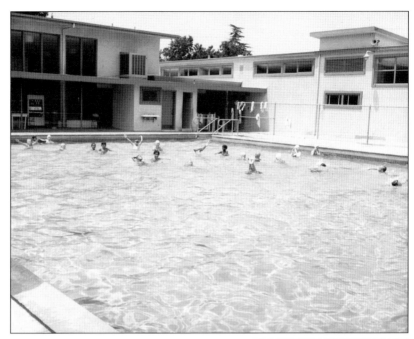

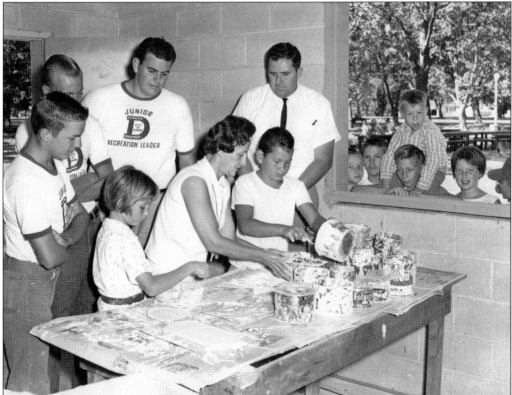

During the 1950s and 1960s, the El Monte Park was home to summertime activities operated by the Dinuba Recreation Department. One favorite was casting and painting plaster objects. Kids would pay 10–25¢ to cast something and paint it. (Martzen Studio.)

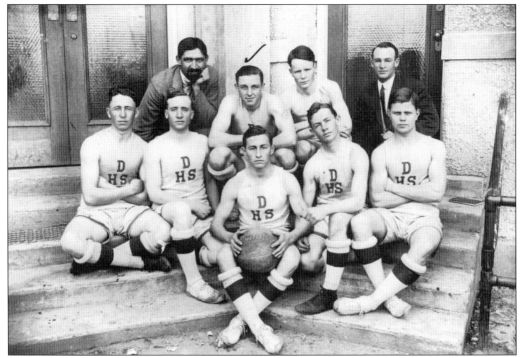

Dinubans have always been avid supporters of the town's sports teams. First was basketball, then football, and lastly, baseball. In 1927, the town went crazy as the high school basketball team won the California state championship. Here is the Dinuba High School basketball team about 1911. (Alta Historical Society.)

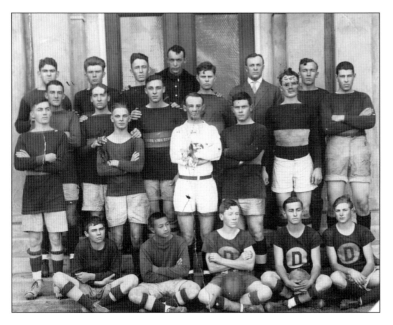

The 1912 Dinuba High School football team is pictured here. Those identified are ? Gordon (first row, far left), Sam KaiKee (first row, second from left), Bryan Snow (first row, far right), Chet Lewis (second row, third from right), Max Newman (third row, far left), Ray Inverson (third row, third from left), Adolf Seligman (fourth row, second from left), Mike Cann (fourth row, fourth from left), and ? Tatum (fourth row, far right). (Alta Historical Society.)

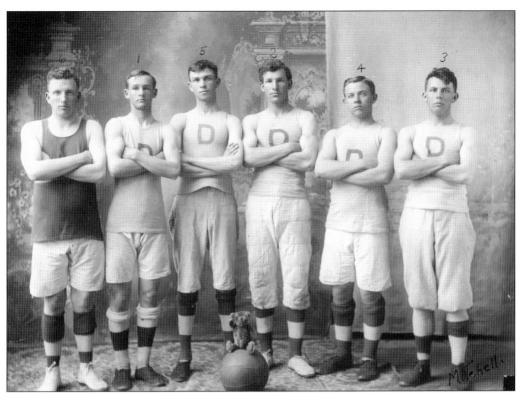

The 1914 Dinuba High School basketball team is, from left to right, Stacey Naylor, Chester Lewis, Robert Blair, Bert Naylor, Roy Archer, and Reuben Nehf. (Alta Historical Society.)

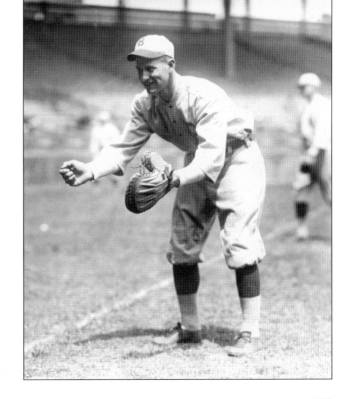

Mac "Buck" Wheat was captain and field manager of the Dinuba Sun Maids, a local baseball team in the Pacific League. Mac played a couple of seasons in the major leagues. His brother Zach was elected to the Baseball Hall of Fame in 1959. (Alta Historical Society.).

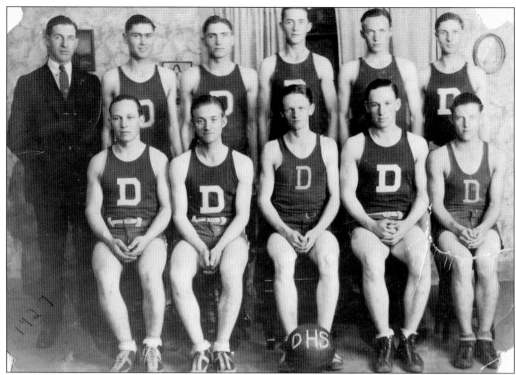

This is the 1927 Dinuba state champion basketball team. Dinuba had a long history of championship basketball and had the largest basketball gymnasium in the central part of California. (Alta Historical Society.)

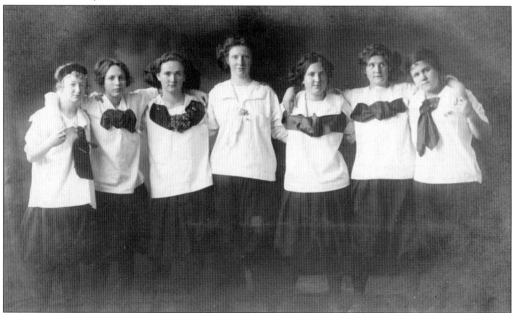

The Dinuba girls' basketball team is pictured in 1912. On March 21, 1912, as part of a celebration, Haddie Leibau wrote, "We BB girls are going to give the BB boys a chicken supper." (Leibau family.)

Eight

RAISIN DAY

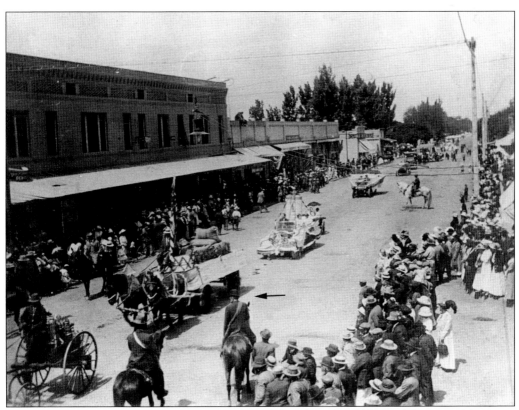

In the summer of 1911, the city trustees determined that there should be a celebration of the raisin harvest, and so began Raisin Day. In this photograph, the arrow points at Judge Wallace, who served as judge until 1924. The parade is in front of the Gusti Building on the corner of Tulare and L Streets. (Alta Historical Society.)

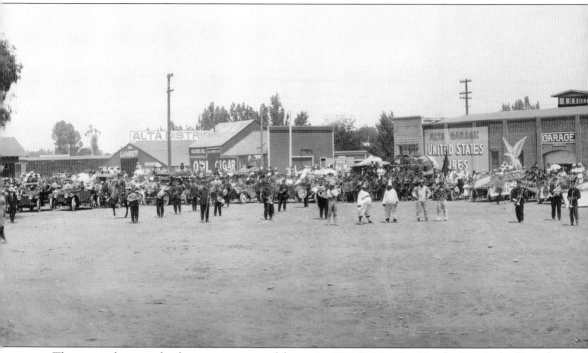

These two photographs show a panorama of the entire 1914 Raisin Day Parade. Dinuba had lost the parade to Fresno for a couple of years, and 1914 marked its return. The center of the photograph

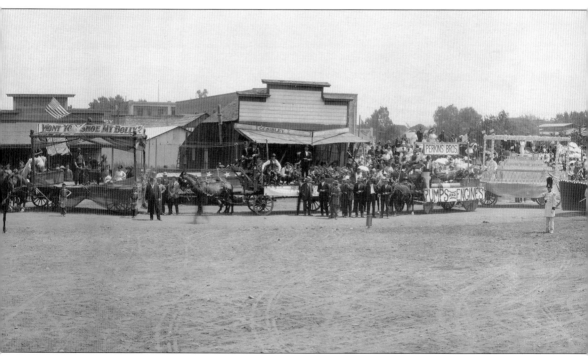

In this picture showing the right half of the 1914 Raisin Day Parade, an arrow points to a float at center right that looks like a large white sheet with a girl in a bonnet seated atop. This is the

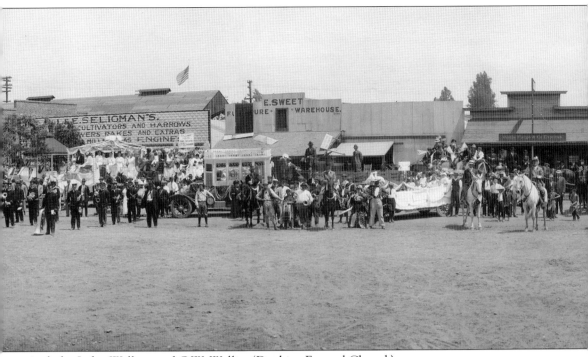

includes Judge Wallace and G.W. Wyllie. (Dopkins Funeral Chapel.)

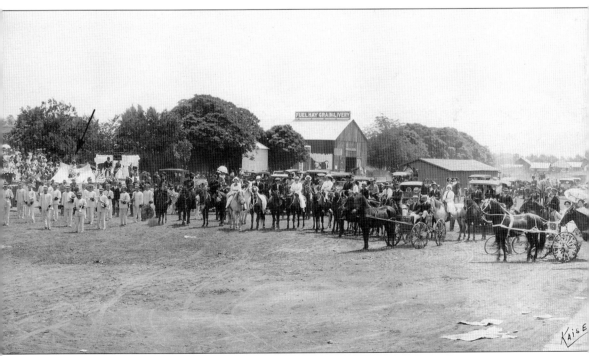

float of the Sun Maid. (Dopkins Funeral Chapel.)

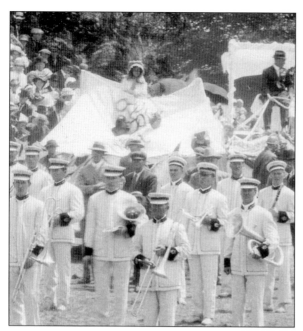

Shown on the float in the 1914 Raisin Day Parade is the original Sun Maid girl, Lorraine Collette Peterson, who became the iconic face of Sun Maid raisins. It became customary in parades to throw small boxes of Sun Maid raisins into the crowds lining the parade route. (Dopkins Funeral Chapel.)

Lorraine Collette Peterson is seen as she appeared in later life. Her face was on every box of Sun Maid raisins for almost 100 years. (Alta Historical Society.)

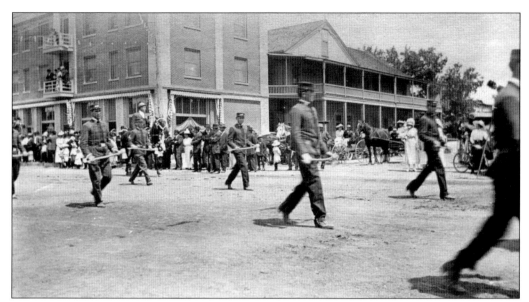

The Woodmen march in the 1911 parade. Woodmen of the World was one of the largest fraternal benefit organizations of the time and went on to become Woodman Life. Woodmen were known for carrying axes in parades. (Janice Moore.)

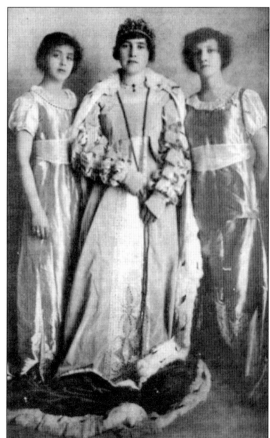

This is Dinuba's First Raisin Day Queen, Clarice Wooley Scruggs, and her retinue in 1914. The Raisin Day Queen evolved into Miss Dinuba and became an annual pageant held in the Dinuba High School auditorium the evening prior to the parade. (Alta Historical Society.)

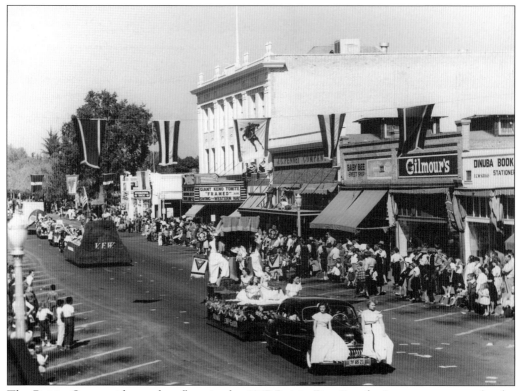

The Raisin Queen rides on her float in the 1947 Raisin Day Parade. It was customary for the Raisin Queen to be the first float in the parade. (Alta Historical Society.)

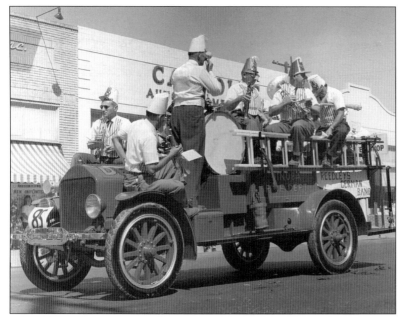

Pictured is the 1916 Garford fire truck, Dinuba's first fire truck, before it was restored, carrying the Reedley German Band in the 1961 Raisin Day Parade. The Garford is a regular in all Raisin Day Parades, even today. (Martzen Studio.)

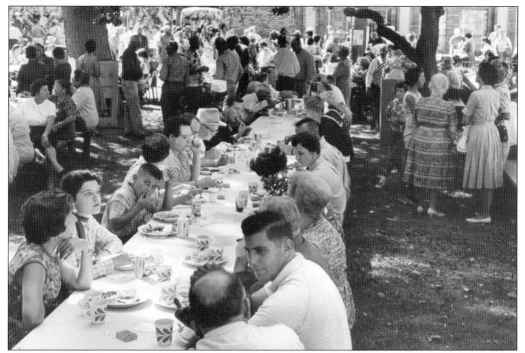

Raisin Day always celebrated diversity in food for all the different groups that had come to Dinuba. Originally, the food booths were on Tulare and L Streets, and a carnival would also come to town. This photograph is from 1961. (Jeff Belknap.)

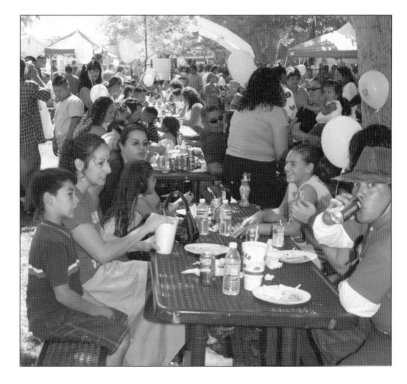

Today, food, fun, and diversity are still major parts of every Raisin Day. For over 100 years, this day has been a time for the community to come together. (Author's collection.)

DISCOVER THOUSANDS OF LOCAL HISTORY BOOKS
FEATURING MILLIONS OF VINTAGE IMAGES

Arcadia Publishing, the leading local history publisher in the United States, is committed to making history accessible and meaningful through publishing books that celebrate and preserve the heritage of America's people and places.

Find more books like this at
www.arcadiapublishing.com

Search for your hometown history, your old stomping grounds, and even your favorite sports team.

Consistent with our mission to preserve history on a local level, this book was printed in South Carolina on American-made paper and manufactured entirely in the United States. Products carrying the accredited Forest Stewardship Council (FSC) label are printed on 100 percent FSC-certified paper.

MADE IN THE USA